DREAMING IN PICTURES

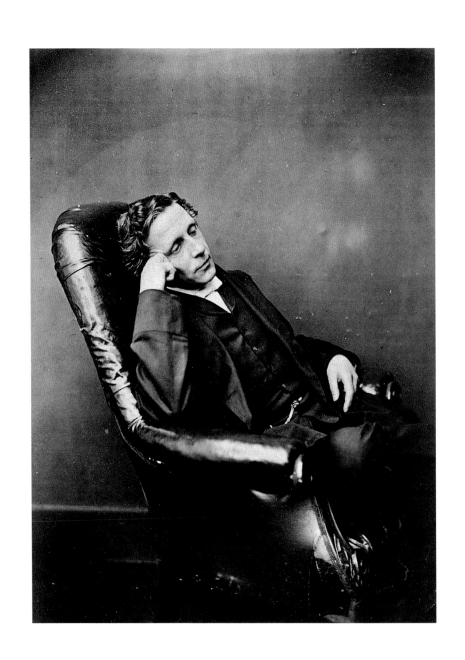

DREAMING IN PICTURES

The Photography of Lewis Carroll

DOUGLAS R. NICKEL

San Francisco Museum of Modern Art

Yale University Press, New Haven and London

This catalogue is published on the occasion of the exhibition
Dreaming in Pictures: The Photography of Lewis Carroll, organized by
Douglas R. Nickel at the San Francisco Museum of Modern Art.
Support for this exhibition has been generously provided by John
Jago Trelawney in memory of his aunt Sallie Benfield.

Exhibition Schedule

San Francisco Museum of Modern Art
August 3 to November 10, 2002

Museum of Fine Arts, Houston
February 22 to May 19, 2003

International Center of Photography
June 16 to September 7, 2003

The Art Institute of Chicago
October 2003 to January 2004

Published in association with Yale University Press, New Haven
and London.

Produced by the SFMOMA Publications Department:
Publications Director: Kara Kirk
Publications Coordinator: Alexandra Chappell
Publications Assistant: Jason Goldman

Editor: Janet Wilson
Designer: Jody Hanson

Library of Congress Cataloging-in-Publication Data

Nickel, Douglas R. (Douglas Robert), 1961–
Dreaming in pictures : the photography of Lewis Carroll /
 Douglas R. Nickel.
 p. cm.
 "Published on the occasion of the exhibition . . . at the San
Francisco Museum of Modern Art, August 3 to November 19, 2002 . . .
[et al.]"—T.p. verso.
 Includes bibliographical references.
 ISBN 0-300-09169-9 (hardback/clothbound)
 1. Photography, Artistic—Exhibitions. 2. Photography of
children— Exhibitions. 3. Carroll, Lewis, 1832–1898—Exhibitions.
I. Carroll, Lewis, 1832–1898. II. San Francisco Museum of Modern
Art. III. Title.
 TR647 .C3594 2002
 779'.092—DC21
 2002006539

Printed and bound in Italy by Mondadori Printing

Front Cover:
Lewis Carroll
Margaret Frances Langton Clarke, 1864
The Art Institute of Chicago. Gift of Mrs. John W. Taylor,
Mrs. Winthrop M. Robinson, Jr., and Mrs. Fred D. Sauter,
from the Estate of Frances Hooper, 1987.211.3

Back Cover:
Oscar Rejlander
Portrait of Lewis Carroll, 1863
Gernsheim Collection, Harry Ransom Humanities
Research Center, The University of Texas at Austin

Frontispiece:
PLATE 1
Lewis Carroll
Charles Lutwidge Dodgson, 1875

TABLE OF CONTENTS

Neal Benezra

The history of modern art is a history of challenges and provocations, of artists determined to question the status quo and, in a century of world wars and technological wonders, rethink society from the ground up. As a museum of modern and contemporary art, our institution was founded with this basic questioning impulse at its core. The self-declared revolutionaries of twentieth-century modernism are therefore accorded a central place in our collections and programming, as are more recent artists who, by extending or reacting against the modernist legacy, continue to keep its ideals the stuff of current debate. The modern spirit did not spontaneously arise in the year 1900, however, and one of SFMOMA's special strengths has been its willingness to investigate the origins of modern culture and modern life, broadly defined. Sometimes the best way to do this is to look at art that does not at first seem to fit our definitions of modernity.

Dreaming in Pictures: The Photography of Lewis Carroll investigates the visual art produced by one of the most famous writers in history. Because of that fame, Charles Dodgson, alias Lewis Carroll, is perhaps the best documented photographer of the nineteenth century: his personal journals, copious letters, and published writings have left a paper trail of unparalleled richness, to say nothing of the immense body of secondary literature that has developed since his death to help explain his genius as a writer and thinker. To reread that genius through the filter of his serious engagement with the camera is to discover not only the uniqueness of his photographic

vision but also the strangeness of Victorian visual culture in general, a culture not yet fully modern, in our conventional understanding of that word, but on the verge of becoming so. The documents—both photographic and textual—challenge us to reconsider our preconceptions about Dodgson, about the role of children in his life and work, and about what a photograph should look like.

If Dodgson's carefully constructed tableau images seem to bear some kinship with those of more recent artists like Cindy Sherman, it may be because the issue of social identity—defined through characteristics like gender or age—remains a modern preoccupation. As Douglas R. Nickel, SFMOMA curator of photography, points out in his essay here, for Dodgson, photography and writing were parallel means of expression that allowed him to explore such issues at a remove, through fantasy and role-playing. The present volume and the exhibition it accompanies are thus, surprisingly, the first to appraise Dodgson's contribution to the medium from an art historical perspective, the first to pay close attention to what the photographs might mean as autonomous artworks and to ask how they spoke to their original Victorian viewers. The story of their fate in the twentieth century—and of Dodgson's popular reputation—holds up a mirror to values and ideas that help us understand our own contemporary condition, and this, it seems to me, is what a museum of modern art should be doing.

A project of this complexity can only be accomplished with the assistance and goodwill of a number of

individuals. For their generosity in lending works or their support to that end we would like to thank Pierre Apraxine and Maria Umali of the Gilman Paper Company Collection; Mark Burstein; Malcolm Daniel and Maria Morris Hambourg at the Metropolitan Museum of Art, New York; Carla Emil and Rich Silverstein; Roy Flukinger and Linda Briscoe at the Harry Ransom Humanities Research Center, University of Texas at Austin; Duncan Forbes and Sara Stevenson, Scottish National Photography Collection, Edinburgh; Sarah Greenough and Earl A. Powell III at the National Gallery of Art, Washington, D.C.; Mimi and Peter Haas; Françoise Heilbrun, Conservateur en Chef at the Musée d'Orsay, Paris; Paul Hertzmann and Susan Herzig; Robert Koch, director of the Robert Koch Gallery, San Francisco; Hans P. Kraus Jr.; Richard Landon of the Thomas Fisher Rare Book Library, University of Toronto; Brian Liddy and John Page, the Royal Photographic Society, Bath, England; Graham Ovenden; Mark and Catherine Richards; Russell Roberts and Paul Goodman, the National Museum of Photography, Film, and Television, Bradford, England; Dr. M. A. T. Rogers; Dr. Paul Sack; Marvin Taylor and Mike Kelly at the Fales Library, New York University; David Travis and James N. Wood of the Art Institute of Chicago; and Margaret Weston. Anne Tucker, Brian Wallis, and David Travis were instrumental in making possible the exhibition's national tour.

Douglas Nickel joins me in thanking these lenders and wishes to acknowledge the many colleagues and friends who have offered their assistance in various ways in the research that has led to the catalogue and exhibition: Peter Bunnell, Sandor and Mark Burstein, Martin Gasser, Nancy Grubb, Anne Hammond and Mike Weaver, Corey Keller, Tirza Lattimer, Karoline Leach, Anne Lyden, Sally Metzler, Ben Primer, Pam Roberts, Genoa Shepley, Roger Taylor, Diane Waggoner, and especially Edward Wakeling, who saved the book's essay from a number of errors, and contributed illuminating comments to the plates. We are equally indebted to the late Carroll scholars Helmut Gernsheim and Alexander Wainwright, who encouraged the project in its earliest stages. At SFMOMA, numerous staff members contributed their time and expertise to this undertaking. Special gratitude is due to Theresa Andrews, associate conservator; Susan Backman, imaging coordinator, Ruth Berson, director of exhibitions; Alexandra Chappell, publications coordinator; Suzanne Feld, curatorial associate, photography; Erin Garcia, curatorial associate, photography; Kara Kirk, director of publications and graphic design; Patricia McLeod, director of development; Kent Roberts, exhibitions design manager; Heather Sears, associate registrar; Jennifer Siekert, exhibitions coordinator; Sandra Sloan, senior public relations associate; Rico Solinas, senior museum preparator; David Sturtevant, head of collections information and access; and Greg Wilson, senior museum preparator. David A. Ross, former director, and Lori Fogarty, former senior deputy director, were early and enthusiastic supporters, as was Sandra S. Phillips, senior curator of photography, without whom the exhibition could not have happened. In addition, Janet Wilson and Jody Hanson brought their customary precision and good taste to the editing and design of this publication, and Patricia Fidler at Yale University Press believed in it when it was only an idea. We would also like to thank Stephen Jaycox and Anthony Amidei of Perimetre Design for their thoughtful craftsmanship of electronic facsimiles of Lewis Carroll albums for presentation in the galleries.

PLATE 2. *Skeleton of* Apteryx australis, 1857

DREAMING IN PICTURES

DOUGLAS R. NICKEL

At the time he published the book that would bring him fame, he was a distinguished lecturer at one of the leading universities in the country. The book features a young girl, who through unexpected circumstances falls into an unhinged world of neurotic adults and bizarre behavior, a world in which she displays a more rational command of the situation than do most of the adults around her. Both comical and dark, in passages even violent, the tale was conspicuous from the moment of its appearance for its want of the expected moralizing message. The author's virtuosity—the splendid embroidery of his prose, his learned allusions and clever wordplay—excused or perhaps simply confounded the disregard of protocol his moral-less story represented. To all appearances he was in demeanor the very embodiment of the sober, upright academician, but even before his death, rumors were circulating about how such singular imaginings must surely have sprung from a personal life harboring deep secrets.

Besides being an accomplished writer, Vladimir Nabokov was also a lifelong enthusiast of butterflies. At age ten he owned a complete library on the subject. The literature credits him with being the first to identify the *Lysandra cormion*, which he discovered in 1938 while hiking in the French Maritime Alps. Upon arrival in the United States in 1940 and having yet to publish anything in English, he took a job organizing the butterfly holdings of the American Museum of Natural History in New York, and then went on to perform similar duties at Harvard, along the way composing several scientific papers based on his research. *Lolita* was written in the early 1950s while the author was roaming the West by car with his wife, seeking new specimens by day and sleeping in motor courts at night—the kind of road odyssey ascribed to Professor Humbert in the book. *Lolita* is, broadly speaking, a novel about the chase, about the force of imagination and a desire for the unattainable. Humbert designates the object of his longing, Dolores Haze, a "nymphet," a little nymph, which any lepidopterist will tell you is the adolescent state of a butterfly as it undergoes metamorphosis. Collecting butterflies was more than a hobby for Nabokov; it was his great passion. He once told an interviewer that if it hadn't been for the Russian Revolution, he would have become an entomologist instead of a writer. His personal collections were meticulously catalogued and preserved—a pageant of lovely, delicate creatures, suspended from life and mounted for display, trophies of the far-flung places to which their pursuer had traveled in their attainment.

Critics have for many years now observed certain affinities between the sensibilities of Nabokov and Lewis Carroll. Both authors enjoyed language for its structured artificiality: Nabokov, because writing in English was a discipline the native Russian felt compelled to make his own, Carroll, because his background in mathematics and formal logic led him to regard language as a delightfully fluid system of signification.[1] Likewise, card games and chess problems recur as themes in the oeuvres of both authors. The royalty depicted on playing cards gave Nabokov the inspiration for his 1928 love triangle, *King, Queen, Knave,* for example, and the psychic crisis of a chess master is the central motif of his novel *The Defense* (1930). Carroll, of course, has Alice confront the King and Queen of Hearts at the end of *Alice's Adventures in Wonderland*, and the characters in *Through the Looking-Glass* play parts consistent with their corresponding pieces on the chessboard. Erudition, even a certain educated snobbishness, comes across in the styles of both men, as their wit often relied upon divining the arcane cultural references lodged in their texts. And, like Nabokov, Carroll had an overweening interest in the concept of innocence and fugitive beauty. He chased photographs.

The advent of a figure like Nabokov in the twentieth century represents a problem for our understanding of Carroll as a Victorian, however, for the lives of the two writers describe not so much a curious parallelism but an intersection. Nabokov was acutely aware of Carroll and the way his mind worked. In 1923, the year after he graduated from Cambridge, he translated *Alice's Adventures* into Russian, an endeavor that, because of the English specificity of the book's puns and homophones,

required Nabokov to inhabit Carroll's voice and rewrite the story in his own cultural idiom. When he came to craft his own famous book in the 1950s, a post-Freudian literature already existed that regarded Carroll as in the thrall of drives and sublimated desires the earlier writer could hardly have been aware of. Nabokov was no fan of Freud, especially when applied to his own writings, but he shared the modern, knowing opinion of his literary predecessor:

> *I have been always very fond of Carroll. . . . He has a pathetic affinity with Humbert Humbert but some odd scruple prevented me from alluding in* Lolita *to his perversion and to those ambiguous photographs he took in dim rooms. He got away with it, as so many other Victorians got away with pederasty and nympholepsy. His were sad scrawny little nymphets, bedraggled and half-dressed, or rather semi-undraped, as if participating in some dusty and dreadful charade.*[2]

In *Lolita*, Nabokov makes Humbert an actual pedophile—a character who recognizes his pathology as such, who even tries to explain it to himself in psychoanalytic terms, who, if nothing else, avoids the charge of hypocritical repression by in fact acting on his impulses. Since then, the vivid image of the leering bachelor professor and his obsession with the girl next door has become exceedingly hard to shake. Seen through the filter of the modern age, Carroll's life and activities—his writings, his photography, his social relationships—all appear suspect, distorted by

a postmortem diagnosis that reduces his biography to deviancy and his creative works to symptoms. To the person on the street, concerned today (for good reasons) with the safety of children, Carroll is assumed to have been some manner of predator, a wolf in sheep's clothing, a perhaps less bold and self-aware version of Humbert. After his first night of debauchery, Nabokov's character drives off, his car grille plastered with dead butterflies. It now seems somehow necessary to pass sentence on the Oxford don before considering a verdict, so concerned are we with what his dusty charades might have entailed for the child-friends who were made to act them out.

Thus the first obstacle encountered in examining the photographs of Lewis Carroll lies in distinguishing between what their creation might have meant to the maker and his Victorian contemporaries and what they may have come to mean since. Charles Lutwidge Dodgson ordered his first camera in March 1856 while a twenty-four-year-old scholar at Oxford, one month after he invented the pen name Lewis Carroll and published his first writings under it, but nine years before the first *Alice* book made that name immortal.[3] The simultaneous invention of two new identities—photographer and lay author—can easily mask the important difference that arose between them, however. After he won fame in the following decade, Dodgson would develop a conflicted relationship with Carroll, a persona that opened doors for him but one he wished to keep distant from his daily life and social interaction. (He was known to leave parties if his authorship of *Alice* was revealed, for example, and would return letters addressed to Lewis Carroll

unacknowledged.)[4] In his more serious publications, to his friends, and in almost all of his other activities he was C. L. Dodgson, and it was Dodgson who made the photographs. The distinction is more than semantic: for over one hundred years, Carroll's status as the creator of one of the most popular children's stories in the English language has governed the terms by which apperception of his photographs has been conducted. If we wish to approach the images on their own terms, as photographs, we must set off by noting how Lewis Carroll and the impresario behind the camera were both alter egos for—different public versions of—one Charles Dodgson.

For over a century, emphasis on the celebrity of their author has had the overall effect of moving discussion of his photographic images from the realm of art history to that of literary history or, worse, hagiography. "Carroll" photographs get inserted into the standard biographies to illustrate what, in that context, becomes the writer's "hobby." Yet we know that although Dodgson first took up photography as an academic's diversion from schoolwork, it evolved into something much more. The camera immediately became a passport for Dodgson, allowing him a particular kind of social circulation and an excuse for meeting persons of high station. He exchanged information with the leading practitioners in Victorian England, published a review of one photographic exhibition, and by 1860 was distributing his own list of 159 photographs for sale. His diaries attest to the expense and difficulty of the undertaking and the sincerity of his ambitions for it—before 1880, one finds in these pages more references to photography than to creative writing. The historical accident of *Alice's Adventures in Wonderland* and the economic independence it afforded him after 1865 facilitated returning Dodgson's photography to that of an amateur, in the sense that he could concentrate his energies on the subjects he most preferred and indulge a more private vision, without concern for market opinion. Over a period of twenty-four years, through a succession of specially built or improvised studios, Dodgson generated about three thousand negatives, carefully annotating the sittings and preserving his best images in a set of circulating albums. He became a recognized figure in elite photographic circles, notorious for his doggedness in procuring subjects. Therefore, if we wish to make a case for Dodgson as a visual artist, the first task has to be to engage his images as if they were *not* known to be the productions of a household name—to show, paradoxically, that the photographs have artistic merit despite the renown of their maker. They must not be prejudged as keepsakes, the by-products of a writer's hobby, but as serious expressions of an innovator demonstrably committed to his medium and the world of pictures.

In our effort to look past the name to see the work, we must also recognize that being open to it now takes a bit of application. The second obstacle to assessing Dodgson's enterprise is the bigger problem of Victorian photography as a whole. We no longer know how to look at it properly, not because the pictures have changed, but because we have. Our understanding of photography is implicitly a modern one; the construction of its history did not begin

until well into the twentieth century. When it did, modernist historians were inclined to assimilate those parts of nineteenth-century practice that could be configured as antecedents to modern strategies and to repudiate the rest. Dodgson's approach to the medium, especially his staged, allegorizing compositions, turned out to be for the most part resistant to modernist appropriation, which accounts for some of what we now perceive as its strangeness. In this regard, it shares a family relationship with the efforts of Victorian contemporaries such as Oscar Gustav Rejlander, Henry Peach Robinson, Julia Margaret Cameron, and Clementina, Lady Hawarden, all of whom are acknowledged by traditional photographic history, but with little sympathy or intelligence. The larger brief for the analysis, then, involves becoming cognizant of the modernist habits of viewing we have learned to bring to work like this, seizing it as an opportunity to attempt to put ourselves in the mental universe of the original Victorian audience. Dodgson's photography may be seen as a case study in the history of reception, both articulating an individual sensibility and betokening his participation in the visual culture of his time.

Lolita's author identified the third difficulty in understanding the work. "Those ambiguous photographs . . . in dim rooms" are ambiguous only insofar as they relate to our opinions about Dodgson's predilection for little girls. Although a conclusive argument can be made that he never

harmed his child-friends in any way—that he would, in fact, have been mortified at the very thought—the photographs he pursued seem to loom as evidence of an unhealthy, *unconscious* interest he took in his young subjects. Their mere creation is seen as an act of sexual dominance and exploitation. Dodgson was undeniably an obsessive and somewhat eccentric character, but the burden falls on us to determine to what degree his photographs signify a real pathology, a Victorian cultural norm that has since shifted, or simply a blank screen upon which we project our own anxieties about the welfare of children. The Reverend Charles Dodgson earnestly subscribed to an ideal of childhood animated by Romanticism—a child's innocence derived from his or her relative temporal proximity to God, he believed, which bestowed a prelapsarian freedom from sin, sexual awareness, and the stultifying effects of society. Wonder, play, and the free reign of the imagination are positive child impulses central to both his storytelling and the making of his photographs. The question consequently becomes: if not a pedophile in life, was Dodgson one in his mind? How did popular belief in the author's abnormality originate in the first place? What kind of psychological evidence does his imagery represent, and what can psychoanalytic models of interpretation accomplish in relating the photographs to a long dead and now silent analysand?

some other occupation

The year 1855 proved decisive in the career of the young Dodgson. In January he returned to his Oxford college, Christ Church, for his fourth year and began tutoring his first students in mathematics. That June the school's new dean, Henry G. Liddell, was appointed and began preparations to install his family at Oxford, and by the fall Dodgson would learn he had been awarded the mathematical lectureship, a position that allowed him financial independence from home and lifetime security. "It has been the most eventful year of my life," he writes in his diary that December:

> *I began it a poor bachelor student, with no definite plans or expectations; I end it a master and tutor at Christ Church, with an income of more than £300 a year, and the course of mathematical tuition marked out by God's providence for at least some years to come.*[5]

In his time, Dodgson's father also had distinguished himself as a Christ Church scholar; he went on to become an archdeacon in the Church of England and in 1843 was given a living in the Yorkshire town of Croft, where Charles came of age. The elder Dodgson was by all reports a pious and grave cleric, who imposed high standards for the education and conduct of his brood of eleven children. He sent Charles to nearby Richmond School at age twelve, then to Rugby. The father's academic connections helped earn his oldest son consideration for a student-ship at Christ Church—what we would call a fellowship—though as a youth he had already distinguished himself in Latin, Greek, English literature, divinity, and especially mathematics.[6] His arrival at college was overshadowed by the sudden death of his mother two days into his first term. In the years that followed, Dodgson is found composing solemn essays on the themes that would mark his adult life: the deceptive nature of physical beauty, the struggle between good and evil, and the merits of pursuing fame.[7]

After matriculating, Dodgson would occasion-ally take the train to London to visit his mother's brother, Skeffington Lutwidge. A barrister by profes-sion, Uncle Skeffington was interested in all manner of optics and gadgetry, including photography. Dodgson joined his uncle in photographing land-scapes around Croft while home from school in September 1855, and was inspired to write a spoof, "Photography Extraordinary," which used the con-cept of photographic development to satirize literary style.[8] Upon returning to Christ Church in January,

Dodgson petitioned his uncle "to get me some photo-graphic apparatus, as I want some occupation here [other] than mere reading and writing."[9] Roger Taylor has argued that Charles's friend and fellow Christ Church student Reginald Southey probably exerted an even greater influence on his decision to take up photography than did his uncle; the diaries find Dodgson admiring Southey's already competent landscapes as early as March 1855, and a year later the two journeyed into London to purchase a camera for Charles.[10] His income having just increased by a factor of six, he could afford to shop for an especially fine apparatus in rosewood.

Even before the camera arrived, Dodgson and Southey were experimenting with a new subject: the dean's children. Photography acted for Dodgson as an entrée to greater familiarity with Liddell and his young family: "Went over with Southey in the after-noon to the Deanery, to try and take a photograph," he writes on April 25. "The three little girls were in the garden most of the time, and we became excel-lent friends: we tried to group them in the fore-ground of the picture, but they were not patient sitters."[11] The apprentices eventually managed to get a good likeness of Harry Liddell against the window in Southey's rooms and were soon back at the Deanery to show off the results and accept an invitation to lunch. Dean Liddell, a noted classicist, was progressive in temperament and would have taken an interest in an innovation like photography; his wife, provincial by birth but socially ambitious, was certainly amenable to seeing her handsome children commemorated. By mid-May of 1856, with

the "Long Vacation" of summer about to begin, Dodgson's camera had arrived, Southey had prepared a stock of processing chemistry for him, and the Liddell children were on standing offer as photographic subjects. "I am now ready to begin the art," his journal declares confidently.[12]

The pattern of Dodgson's photography at its incipience shows what might well have been predicted: he tackled landscapes and a few other genres but was primarily drawn to portraits, usually of sitters close at hand. On visits to Croft he composed images of friends and relatives—some of them mildly droll, such as that of his brother Skeffington in fishing waders and cravat, taken in August 1856, and a likeness of the family dog.[13] While he continued making family photographs throughout his career, by 1857 another kind of vision was taking shape. A portrait of Annie Coates, the daughter of Croft's grocer and poulterer William Coates, places her outside the henhouse, her boots and shirtsleeves creating a scenario of rustic livelihood (pl. 22). A few months earlier Dodgson had ventured a study of the Liddells' daughter Alice, age five, posed—as she would be again, more successfully, the next summer—as a beggar-maid (pl. 21).[14] In August he was delighted to make the acquaintance of Mrs. Anne Weld and her daughter Agnes Grace, doubly so, as he indicates in his diary, because not only was Agnes "very striking and attractive, and will certainly make a beautiful photograph," but her mother turned out to be Alfred Tennyson's sister-in-law.[15] In one of the photographs made on the occasion, Agnes is posed against an ivy-covered bower, clutching a hooded cloak and toting a

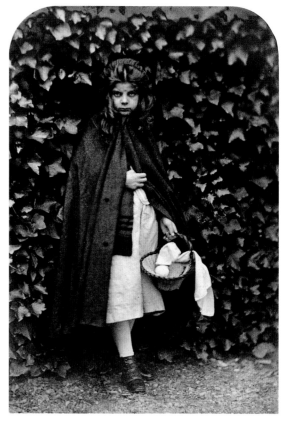

Figure 1. Lewis Carroll. *Agnes Weld as "Little Red Riding-Hood,"* 1857. Gernsheim Collection, Harry Ransom Humanities Research Center, The University of Texas at Austin.

basket (fig. 1). Dodgson exhibited the work the following January at the Photographic Society in London under the title *"Little Red Riding-Hood."*[16]

The initiation of such studies, which involved costumes, role playing, and greater attention to staging, signals an important departure. In 1856 the photographer began assembling his portraits into albums that were circulated in and around Oxford in an effort to keep the most successful ones together and demonstrate his approach to potential sitters and their parents.[17] Such photography was an essentially genteel affair, conducted between Dodgson and

persons in his social circle. In sending framed works for display at the Photographic Society, however, and in now giving them titles derived from literary sources, Dodgson was testing the waters in a more public realm. Correlative to this was the idea that photography might perhaps be made gainful. After securing his master's degree in February 1857, Charles was forced to relinquish one of his undergraduate scholarships and his job as sublibrarian, to the tune of £60 per year. Recording this loss, he notes in his diary:

> Collyns, (of Drayton), tells me that there is a fund belonging to Ch. Ch. at present in Chancery, to be apportioned somehow to the encouragement of Physical sciences, and that the Chancellor would be willing to make an order on it for any college officer, provided it could be somehow brought under that category. He says it was suggested in Common Room that my cultivating photography might entitle me, as a college tutor, to claim some of it.[18]

Nothing seems to have come of the idea, but the same year Dodgson began a campaign to secure portrait likenesses of Oxford worthies and visiting dignitaries. On June 15, for example, he photographed Quintin Twiss, a promising actor and Christ Church undergraduate, in both street clothes and costume. "I intend trying these at Ryman's [picture gallery], to see if I can in any way make photography pay its own expenses."[19] Over the next three years he collated hundreds of negatives of fellow dons, churchmen, and university personnel and was delivered a windfall in 1860, when the British Association for the Advancement of Science met at Oxford. Brought together in one place were the best minds in Victorian England (including Thomas Huxley and Bishop Samuel Wilberforce, who famously debated natural selection at that occasion). In 1860 Dodgson had printed a four-page list of photographs for sale, which included 106 portraits (individuals and groups, forty-five of them Christ Church men), some architectural subjects, and studies of sculpture and natural history subjects.[20] He evidently continued this project into the 1860s, securing permission from famous sitters to publish their portraits, sometimes vending studies of children to their happy parents.[21] Dodgson created almost a thousand negatives between 1857 and 1862, his most active period in photography, and while the degree to which remuneration offset expenses is impossible to calculate, characterizing his first years with a camera as strictly those of an amateur clearly misconstrues something of his ambition at the time. The fact that Dodsgon's list included no photographs of the Liddells, Agnes Weld, or other costume studies of children suggests that this kind of photography remained a separate sphere of activity for him. It would soon predominate, courtesy the hand of fate, but there is no telling what kind of career in photography the fixed-income academic might have negotiated had it not been for that *deus ex machina* that was about to change his life.

On 4 July 1862, Dodgson inserts in his diary:

Atkinson brought over to my rooms some friends of his, a Mrs. and Miss Peters, of whom I took photographs, and who afterwards looked over my albums and stayed to lunch. They then went off to the museum, and Duckworth and I made an expedition up the river to Godstow with the three Liddells: we had tea on the bank there, and did not reach Ch. Ch. again till quarter past eight, when we took them on to my rooms to see my collection of micro-photographs, and restored them to the Deanery just before nine.[22]

The laconic entry belies the significance of the event. The day that began and ended with photographs included a rowing trip on the Isis, with Lorina, Alice, and Edith Liddell and accompanied by his friend Robinson Duckworth, during which the girls browbeat Dodgson into telling them a story to pass the time—the story of Alice and her adventures underground. Each of the participants was rendered as a character—Alice, the heroine, with Duckworth as the Duck, Lorina the Lory-bird, Edith the Eaglet, and the narrator himself the Dodo.[23] Even Dinah, the Liddells' cat, got a part. Duckworth recalled the incident later in life:

I rowed stroke *and he rowed* bow *in the famous Long Vacation voyage to Godstow, when the three Miss Liddells were our passengers, and the story was actually composed and spoken over my shoulder for the benefit of Alice Liddell, who was acting as "cox" of our gig. I remember turning round and saying, "Dodgson, is this an extempore romance of yours?" And he replied, "Yes, I'm inventing as we go along." I also well remember how, when we conducted the three children back to the Deanery, Alice said, as she bade us good night, "Oh, Mr. Dodgson, I wish you would write out Alice's adventures for me." He said he would try, and he afterwards told me he sat up nearly the whole night, committing to a MS. book his recollections of the drolleries with which he had enlivened the afternoon. He added illustrations of his own, and presented the volume, which used often to be seen on the drawing-room table at the Deanery.*[24]

It took Dodgson two and a half years to complete the manuscript, illustrated with his drawings and closing with a pasted-in photograph of Alice, which he presented to his muse as a Christmas present in 1864. Prior to making the gift, he shared the story with his friend George MacDonald, who, as the author of *Phantastes* (1858) and other fairy tales, had expertise in the genre, and MacDonald in turn shared it with his wife and household full of children. They urged Dodgson to publish the story. Through his Oxford friend Thomas Combe, head of the Clarendon Press and a patron of the Pre-Raphaelites, Dodgson made arrangements to have the book brought out by Macmillan, with illustrations provided by the noted *Punch* caricaturist John Tenniel. Alice's manuscript, which Dodgson called "the germ" of the published

work, was greatly altered and more than doubled in length; scenes such as the Mad Tea Party now appeared, and the trial at the conclusion was expanded to encompass two chapters. The title also changed, from *Alice's Adventures Underground* to the flossier *Alice's Adventures in Wonderland*, as the story ad-libbed for three neighbor girls, with its in-jokes and familiar references, was polished into literature for popular consumption. Dodgson bore all the costs of production and in 1865 anticipated taking a loss on the whole affair; instead he unleashed one of the most profitable children's books in history. The strong sales encouraged him, within a matter of months, to begin planning the sequel.[25] *Alice* and *Through the Looking-Glass* won the Oxford mathematician inadvertent fame in a vocation that earlier he would hardly have deemed exalted, and popularized the pseudonym on the front cover in a way that would vex him the rest of his life.

His photography, while betraying signs of his mature interests prior to 1862, came into its own in the years surrounding the *Alice* books. Dodgson trundled his camera and darkroom outfit with him when he traveled, but back in college he had been making the Deanery and its gardens his unofficial headquarters. In April 1863 he decided that a permanent studio was needed, probably inspired by a visit the previous month to the London atelier of Oscar Gustav Rejlander. Rejlander, whose work Dodgson found "very beautiful," was one of the preeminent photographers of the day, known for his allegorical compositions and nude studies of women and children, as well as his portraits.[26] To celebrate the genial

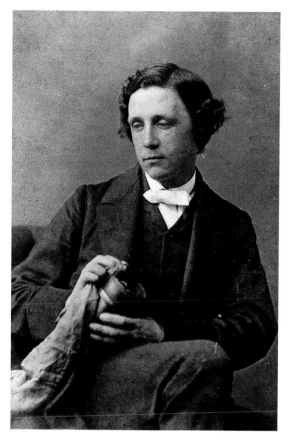

Figure 2. Oscar Gustav Rejlander. *Portrait of Lewis Carroll*, 1863. Gernsheim Collection, Harry Ransom Humanities Research Center, The University of Texas at Austin.

interchange they enjoyed, Rejlander made a portrait of Dodgson, lens in hand (fig. 2). When Dodgson located an appropriate space to rent, behind Richard Badcock's upholstery shop on St. Aldates Street, Oxford, he asked Rejlander to visit and give his advice about it.[27] A month earlier, Dodgson had listed in his diary the names of 107 girls "photographed or to be photographed"; now, under the skylight of an indoor studio, he could concoct elaborate scenarios with more predictable results and spend less time assembling and disassembling his apparatus.[28] The privacy here also facilitated more natural (that is

to say, less distracted) behavior on the part of the children, as well as more seclusion for the posing of notables, such as Crown Prince Frederick of Denmark, whom Dodgson convinced to sit for him in November of that year.[29] He still improvised most photographic settings in the field, but possession of a studio undoubtedly gave the artist a greater sense of purpose about what he was doing.

In June 1868 Archdeacon Dodgson died after a brief illness. The thirty-six-year-old Charles was now the eldest male in the family and assumed responsibility—symbolically if not practically—for the welfare of his several maiden aunts and sisters, removing them from the rectory at Croft to a house in Guildford, near London. By this time a senior member of his school, Dodgson himself moved the same year to new quarters in Christ Church, a suite of ten rooms on Tom Quad described as "perhaps the largest College set in Oxford."[30] Here he outfitted a darkroom and converted the sitting room into a veritable playground for young visitors, its cupboards filled with music boxes, dancing dolls, a mechanical bear, books, puzzles, and costumes that would be donned if photography was contemplated. One advantage of the new quarters was the rent saved by giving up the Badcock Yard studio, but it was three years before he could gain permission for, and complete construction of, a new studio on the roof of his residence.

However, the pace of Dodgson's photography was declining in these years, in direct relation to his increased publishing activities and other duties. Nearly all of the pictures created between 1872 and 1880, when he stopped photographing altogether, were made in the rooftop studio, some of them among his best. He also used the studio to renumber and organize his vast collection of negatives, collate his albums, and make new prints when needed. Dodgson took his collection seriously; at least eleven of these albums survive, most with a handwritten index at the beginning, and several with manuscript poetry or the sitters' autographs adjacent to the prints.[31] A compulsive archivist of his own life, Dodgson records having spent three weeks in August 1875 reviewing his photographic stock:

> *Another week has gone exactly like the last, in photographic registering etc. and going through and destroying old letters. I have now got the alphabetical index of negatives arranged and nearly complete, written up the chronological register nearly to date, numbered, by it, all unmounted prints and mounted cartes and cabinets, and arranged them, numbered nearly all mounted in albums, and entered in the register references to them, and gone through all the 4¼ x 3¼ and 6 x 5 negatives by means of the register, erasing some, finding places for others, and making out an order for new prints to be done by Hills and Saunders.*[32]

He prepared a similar index of his papers, which included every letter he had sent or received, along with a brief summary of its contents. At the end of his life, 98,721 items were registered.[33]

Dodgson did not quit photography in 1880 so much as digress from it. His summers—formerly the time of year when most of his photographic activity took place—were now spent without a camera at the seaside resort of Eastbourne, committed wholly to writing projects. The school year was largely reserved for college business; indeed, that, too, became so demanding that Dodgson soon decided to resign his mathematical lectureship. In 1885 he wrote to his friend the artist Gertrude Thompson, "It is 3 or 4 years now since I have photographed—I have been too busy," referring no doubt to the fifteen or so publication projects listed in his diary earlier in the year.[34] He satisfied occasional picture-making inclinations by taking up life drawing, which dispensed with the mess and tedium of darkroom work, though he kept the studio available and for some time continued making arrangements for sitters, as if his photography might resume at any time. The reasons given for why it did not—ranging from a reaction against the arrival of dry-plate negatives to a scandal in Oxford over his nude studies—are all more interesting than what is probably the truth; the now-celebrated author had devoted twenty-four years to photography, a long career by contemporary standards, and had achieved remarkable results. After 1880 he moved on to other things.

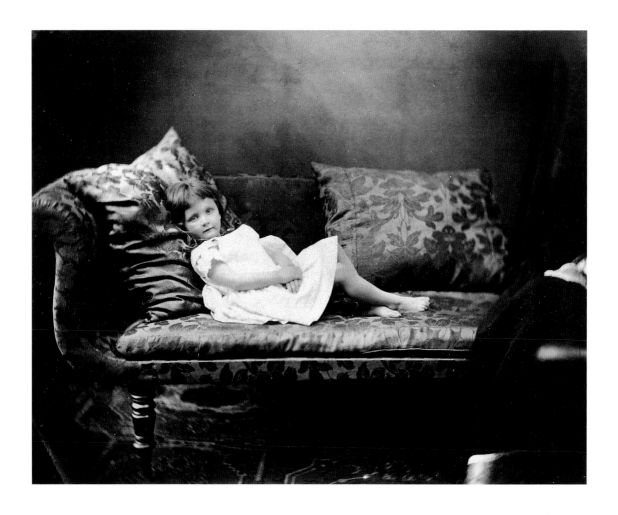

PLATE 3. *Alexandra "Xie" Kitchin*, 1869

a tangled tale

D odgson achieved his most memorable photographic results in the 1860s and 1870s—years of intense activity dominated by the publication of *Alice's Adventures in Wonderland* (1865), *Phantasmagoria* (1869), *Through the Looking-Glass* (1872), and *The Hunting of the Snark* (1876), as well as scores of pamphlets, poems, games, and mathematical papers. It was also a period of extraordinary social interaction, university politicking, and personal upheaval. One of the great controversies among Carroll scholars today involves the circumstances surrounding Dodgson's reputed break with the Liddell family in June 1863, which has become a source of rampant speculation on the part of later biographers. Falling chronologically as it does between the river trip and the publication of *Alice*, this sudden cooling of relations has catalyzed biographical conflation of the author's private life with his fictional products. Since received opinion about Carroll's purpose in photography has been so inflected by a line of thought that can be traced back to this incident, it is worth sorting out what is known from what is simply conjecture.

Assessment of the vicissitudes of Dodgson's actual relations with the Liddells is hampered by the fact that, sometime after his death, his heirs reviewed the contents of his personal journals and decided to expurgate those sections or whole volumes that they thought might put their kinsman in a bad light. The period from April 1858 to May 1862 is thus completely missing, while the journals that survive have certain lines crossed out or pages removed. Dodgson's siblings were reserved to an extreme, anxious to protect both domestic matters and their idiosyncratic brother's reputation from any posthumous scandal, and to that end they assisted a nephew, Stuart Dodgson Collingwood, in writing the first official Carroll biography in the year of his death, titled *The Life and Letters of Lewis Carroll (Rev. C. L. Dodgson)*. Though Collingwood had complete access to the diaries and letters in the estate, he was careful to fashion an uncomplicated version of *Alice*'s author, one that would accord with family sentiment and public taste alike. For this reason the book is largely silent on the details of the writer's private life, emphasizing anecdotes and personal reminiscences instead and devoting great attention to Carroll's fondness for children.

We will never know for certain what Collingwood and the other Dodgson relatives read in the diary entries for 27 to 29 June 1863, as the pages were razored out and apparently destroyed. However, it is clear that something caused Dodgson and the Liddells to suspend contact for more than five months, and when the diary resumes, it finds the writer holding himself "aloof" from them.[35] Collingwood mentions

nothing of these difficulties but does allow "that the shadow of some disappointment lay over Lewis Carroll's life."

Such I believe to have been the case, and it was this that gave him his wonderful sympathy for all who suffered. But those who loved him would not wish to lift the veil from these dead sanctities, nor would any purpose be served by so doing.[36]

The nephew refers here specifically to some love poetry Dodgson wrote: "Three Sunsets," describing a star-crossed relationship, composed in November 1861, one of the missing years in the diaries.[37] But he and his fellow executors were adamant about not "lifting the veil" of what was recorded in those pages. Denied access to Collingwood's sources, later biographers were forced to either repeat versions of his bland characterization or invent new ones based on the scanty data available. Florence Becker Lennon, an American writer, enhanced Collingwood's picture of Carroll as a saintly, childlike figure with a fresh assertion. In her *Victoria Through the Looking-Glass* (1945), she suggests that not only did Dodgson avoid adult society in preference for that of children, but also that ten-year-old Alice Liddell, his "ideal child-friend," was, in fact, both muse and the object of a romantic obsession. "Carroll was actually in love with [her], and proposed honourable marriage to her," Lennon spontaneously reports.[38] Seven years later the British author Alexander Taylor concurs: "There is no doubt in my mind that Dodgson was in

some sense in love with his heroine or that the break-down in their relationship which occurred as Alice grew up was the real disappointment of his life."[39] Though unsubstantiated, the idea, once planted, appeared as a key to unlocking the mystery to which Collingwood alludes, explaining why caretakers would remove pages from Dodgson's diaries in precisely those sections leading to his break with the Liddells. The thirty-year-old Charles's supposed love for Alice and the proposal of marriage that her protective parents would have rejected were adopted as credible contentions by all subsequent biographers and became part of popular lore. As recently as 1995, Morton Cohen would compound the story, offering gossip, elliptical correspondence, and the existence of other "May-December" marriages in the Victorian period as grounds for its acceptance.[40]

A romantic love for the actual Alice is just one of the legends that have grown up around Lewis Carroll, serving to connect the personal history of the brilliant author more directly with his fictional creation. Karoline Leach has demonstrated the tenacity of these myths and the way they have colored most modern interpretations, even in the face of logic and much contravening documentation. That Dodgson had no particularly strong feelings about Alice Liddell in the 1860s is manifest from his diaries, where she is seldom mentioned, and even then in often unflattering ways.[41] Although it is true that she did prompt him to write down the story he had told on the boating trip, the character of Alice in the book is just that, an invention of Dodgson's imagination, with only a generic resemblance to her namesake.

(Indeed, the Alice we picture from Tenniel's illustrations bears no resemblance to the Liddell girl, having been drawn from the illustrator's fancy.) This became part of a larger myth—quite the opposite of reality—that found Dodgson morbidly shy of adult company, comfortable only around little girls. The historiographic phenomenon Leach describes—one that limits Carroll's amorous inclinations to female children in general and Alice in particular—has informed unspoken assumptions about every other aspect of his life, the irony being that the mythology that has made Carroll so suspect to modern eyes was originally crafted to protect him.

When Dodgson's family authorized Collingwood to write his biography in 1898, Lewis Carroll was already a famous name, but Charles Dodgson was the source of a certain embarrassment for his highly decorous relatives. One of the conditions of his appointment at Christ Church was that he remain unmarried, and by Oxford regulation he was expected to progress from deacon to ordained priest.[42] An imposed bachelor status did not keep Dodgson from cultivating a great number of friendships, however, not only with children, both boys and girls, but also with men and grown women. As a young man setting out on an academic career, he could still contemplate the possibility of one day leaving the university to marry, but once settled in his course, he made the best of the situation by operating at the outer limits of Victorian convention.[43] Rumors circulated around Oxford of Dodgson's trips to the seaside with young ladies, of his staying overnight in the homes of widows or married women whose husbands

were away, and several of his "child-friends" grew into teenagers and then women, with whom he maintained regular contact. His rather normal male penchant for the company of winsome young (and not so young) women might have been tolerated by his relations if his children's books had not made Carroll an object of great public interest. In response, the protective Collingwood, on behalf of the family and in the spirit of the age, fabricated in his pages a guileless Carroll designed to quell interest in the more problematic Reverend Mr. Dodgson.[44]

Collingwood accomplished this in a characteristically Victorian way. It was understood at the time that a girl was not a sexual creature until she had passed through puberty; after the age of fourteen, she was liable to attract sexual attention, but before then the idea was unthinkable in polite society. A bachelor who consorted with girls fourteen and older, as Dodgson did, was likely to be suspected of impropriety, but to say that a man confined his affiliations to the society of children was, in contemporary parlance, to declare him utterly safe.[45] This is precisely what Collingwood attempted to do. His book is dedicated "to the child-friends of Lewis Carroll" and concludes with two chapters that expand on the topic. Here he asserts that "from very early college days began to emerge that beautiful side of Lewis Carroll's character which afterwards was to be, next to his fame as an author, the one for which he was best known—his attitude towards children, and the strong attraction they had for him."[46] When a girl reached the age of consent, the biography insisted, Carroll would refrain from continued contact.[47] His supposed aversion to

boys was also mentioned in passing. Collingwood's focused attention on his uncle's fondness for little girls, while not untrue, was a deliberate diversion from an uncomfortable reality, such that the figure who emerges from his book is virtuous, devout, retiring, modest, asexual, charmingly eccentric, and completely unthreatening.

At the time of Dodgson's death, many of his former child-friends came forward and willingly acceded to this image of the man. The complications did not begin until the 1930s, at the end of two decades that saw Sigmund Freud's complete works translated into English and introduced to the cocktail set. The generation of moderns, born at the end of the Victorian period, now had in Freud an effective means of discrediting it, as their own newly sophisticated understanding of sexuality could be contrasted with what became stereotyped as Victorian "repression." In 1933 a clever student named Anthony Goldschmidt submitted a four-page article to the *New Oxford Outlook* titled "'Alice in Wonderland' Psycho-Analysed." The appearance of Goldschmidt's essay represents a decisive moment in the history of the subject, for it marks the birth of Lewis Carroll as a sexual deviant.

Goldschmidt argues that because *Alice* was an impromtu creation of Carroll's on his river trip—simply "the first thing that came into his head"—the original story motifs more closely approximate the free associations of Freudian analysis than they do the willful inventions of the author's conscious mind. The narrative takes the form of a dream, he points out, and its incidents and images seem not only sub-

conscious in nature but also erotic. The imagery is sexual: Alice runs into a rabbit hole and falls down what appears to her a very deep well. "Here we have what is perhaps the best known symbol of coitus." Next she pursues the White Rabbit through a series of passageways: "the pursuit in dreams of something we are unable to catch [may be seen] as representing an attempt to make up a disparity in age." Confronted with a number of locked doors, the dreamer (the narrator, here identified with the protagonist, Alice) discovers that the tiny golden key in her hand is useless on every door except a small one hidden behind a low curtain.

> *Here we find the common symbolism of*
> *lock and key representing coitus; the doors*
> *of normal size represent adult women.*
> *These are disregarded by the dreamer and*
> *the interest is centered on the little door,*
> *which symbolizes a female child; the curtain*
> *before it represents the child's clothes.*[48]

Alice grows and shrinks, suggesting phallic significance; the sneezing baby implies an autoerotic event. The account concludes that "it is difficult to hold [Carroll's] interest in children was inspired by a love of childhood in general, and in any case based on a mental rather than a physical attraction, in view of two facts: that he detested little boys . . . and that his friendships almost invariably ended with the close of childhood."[49] Not knowing that these "facts" were mostly biographical inventions, Goldschmidt could only surmise that Carroll's text indicated "the pres-

ence, in the subconscious, of an abnormal emotion of considerable strength."[50]

"'Alice in Wonderland' Psycho-Analysed" was but the first in a string of studies that began discovering subconscious Freudian symbolism everywhere in Carroll. Soon William Empson would decide that the *Alice* stories represent a battle between carnality and intellect; the Red Queen personifies "uncontrolled animal passions," while the Cheshire Cat, with his disappearing body and floating head, symbolizes Dodgson's ideal of emotional detachment from the world of sexualized beings. Wonderland is here an allegory of reproductive development; the saltwater in the pool of tears returns Alice to the womb, as going down the hole she first signifies the father, then at the bottom a fetus, and, lastly, a child, "only born by becoming a mother and producing"—by crying—"her own amniotic fluid."[51]

Several authors, beginning with Langford Reed, saw in Dodgson's discomfort with Carroll evidence of a split personality.[52] In 1955 Phyllis Greenacre, a professor of clinical psychiatry in New York, wrote the most extended of these analyses, in which she discovered the "psychic structure" of the author's works in various incidents of his childhood. She ascribed the ill treatment of babies in the *Alice* books (where they are tied in knots or turned into pigs) to the jealousy Dodgson felt toward the succession of newborns that came along to displace parental attention in his youth. As an adult, seeing the Liddell girls playing in the Deanery garden, he experienced feelings of regression, according to Greenacre, as he identified them with his companionate sisters and the idyllic garden

memories of home. Dodgson's letters to children, in which he playfully suggested, for instance, flattening cats into pancakes, are connected to aggression toward boys; the development of his mathematical ability turns out to have been a "neurotic compulsive defense" against fears of an overly imaginative nature.[53] And, perhaps inevitably, his "intense, unconsummated love" for little Alice Liddell indicates a "reversal of the unresolved oedipal attachment" caused by the early death of his mother: the impossible age difference between him and these two females locked Dodgson in a state of arrested development,

"a man who seemed never to love another woman, but to live as a child, still in the magic garden, devoted only to little girls not yet across the mystic bar of puberty."[54] What all of these studies have in common is an attempt to synthesize information culled from Dodgson's life history with expressive elements in his writing. Psychological abnormality was a given. In retrospect, we realize this was theory built on theory—an intellectual house of cards, as Freudian concepts were applied to legends, conjecture, and half-truths.[55] At its center lies Dodgson's fixation on little girls, now firmly established.

a ride on a lion

───────── ◆ ─────────

Carroll's photographs entered history at the same moment he did. Stuart Collingwood included not only a number of ink sketches and other visual artifacts in his 1898 biography but also twenty-nine of his uncle's camera studies. Not surprisingly, their appearance in this context does little more than lend concrete factuality to the life story being narrated; eighteen depict famous adults, such as Tennyson and John Ruskin, two are landscapes from the family homes in Yorkshire, three show notables posed beside their children, and, of the six portraying girls, four feature Alice. The following year Collingwood edited a small miscellany, *The Lewis Carroll Picture Book*, employing the same approach. Thus the institution of valuing Dodgson's photography as essentially documentation of his social world finds its source in the agenda of the family-sanctioned memoir; Collingwood had his uncle's entire estate at hand—some thirty-four albums and an untold number of loose prints—and chose to stress the eminent Victorians. Carroll as an *expressive* photographer is first encountered in 1915, in the twilight of the Photo-Secession movement. In January of that year, Alvin Langdon Coburn opened "An Exhibition of the Old Masters

of Photography" at the Albright Art Gallery in Buffalo, New York, presenting early calotype portraits by Hill and Adamson and Dr. Thomas Keith, twenty works by Julia Margaret Cameron, and ten by Carroll. At a time when nothing equivalent to what we would call the history of photography had yet come into existence, this early effort to construct a nineteenth-century canon of "masters" was clearly predicated on the politics of the contemporary art world, which still rejected the idea that photography might be seen as a legitimate creative medium comparable to painting. "How consoling it is to think," writes Clarence White of the selection, "that the progress of photography is left, not in the hands of calculating professionals, but in those of the amateur whose sincerity of approach has made photography become indeed a medium of personal expression. This is why we are glad to see these 'Old Masters' and this is why we thank those who allowed us such an opportunity."[56] If Collingwood appropriates the photographs to support his testimonial, Coburn does so to find prototypes constructing a lineage for art photography that is predicated on qualities of directness, aesthetic purity, and what he viewed as independence from any taint of commercialism. Carroll is selected from among scores of nineteenth-century practitioners because his reputation in another field guarantees his photography to be the high-minded, disinterested avocation of a gentleman who moved in artistic circles.

The cultural distance from the 1860s can already be felt in these offerings. Although 1932 brought a spate of exhibitions and articles commemorating the centenary of Dodgson's birth, his imagery per se did not become a matter of scholarly inquiry until 1949, when Helmut Gernsheim, a historian of photography, published the first full-length monograph on his work, *Lewis Carroll: Photographer*. Gernsheim had studied art history in his native Munich before immigrating to England in 1937. A trained practitioner, he served as photographer at London's Warburg Institute during the war, married an Englishwoman, Alison Eames, and in the mid-forties met the American photo-historian Beaumont Newhall, who encouraged his collecting and research. Gernsheim's monograph ushered in our modern understanding of Carroll's photography; by isolating it for discussion, he underscored the extent of Dodgson's commitment to picture-making but also clearly struggled to appreciate, from a mid-twentieth-century perspective, what the pictures meant. His intellectual engagement with Carroll was unpremeditated:

> It is a remarkable coincidence that while collecting material for my biography of Julia Margaret Cameron my attention was drawn to an album of another great mid-Victorian amateur photographer—Lewis Carroll. Turning its pages, I was struck first by the fertility of his imagination; later I became aware that each picture possessed a strong individual character, and the more I studied the 115 photographs it contains, the more I was convinced that here was a genius at work, the like of which is rare in nineteenth-century photography. . . . Curiosity led to eager research, for quite frankly until then Lewis Carroll, photographer, had been a stranger to me.[57]

Gernsheim's study of Cameron had been published the year before, in 1948, so it might be justifiably argued that his conceptions of Carroll and Cameron developed in tandem. He reveals that he gravitated to Cameron because she appeared to belong to "that select group of English eccentrics who always fascinated me," and his study was based on that perception, Gernsheim recognizing something of himself in her "very picturesque and eccentric personality," "a woman caring little for the conventions of her period, living her life according to her own will."[58] Carroll thus emerges as Cameron's foil: both were amateurs, practicing their art in the same patrician circles, and both were eccentric, willing to importune even the most exalted luminary for the sake of photography, but whereas Cameron was outgoing, self-assured, and utterly individualistic in her approach, Carroll appeared the reverse. "Mrs. Cameron was urged on by great ambition," he concludes, "and her work is the expression of an ardent temperament. Lewis Carroll had no ambition; his art springs from delight in the beautiful; he is feminine and light-hearted in his approach to photography, whereas she is masculine and intellectual."[59] Carroll thus provides an effective counterpoint to Cameron's greatness, demonstrating how the same socioeconomic circumstances might produce diverse levels of achievement. Cameron penetrated her sitter's countenance to reveal his or her inner character; Carroll sought only "attractive design," and therefore realized, at his worst, "facile characterization," at his best, "charm, grace and naturalness."[60]

Gernsheim saw Carroll's photography as falling into "two clearly defined categories—distinguished people, and children." Given what he had read in the literature of Dodgson's purported reticence, he had no problem apprehending why the pictures of adults seemed stiff and aesthetically inferior. However, "the shy, pedantic mathematical lecturer completely unbent in the company of little girls, whom he never tired of entertaining." Thus Gernsheim's selection of pictures for inclusion as illustrations in the book was predicated upon a determined editorial stance; he inverts Collingwood's ratio, reproducing twice as many studies of children as of adults. His qualitative reasons for the decision are stated plainly: "In considering his portrait work as a whole, the photographs of children are of infinitely greater artistic value than the portraits of the famous, and we feel sure that the enchanting portrait of Beatrice Henley . . . meant more to Lewis Carroll than the dull portrait of the Crown Prince of Denmark."[61] "Beautiful little girls had a strange fascination for Lewis Carroll," Gernsheim adds to the chorus, insisting it was an enchantment that ceased "when the girls put up their hair."[62]

Gernsheim's study became a breeding ground for future misinterpretation. His method in treating both Cameron and Carroll—a method that supported claims for their identification as true artists—was to read the work as a direct reflection of their unique personalities.[63] Highlighting their complete detachment from the realm of professional photography made it clear that their pictures served no other master than their temperaments. Gernsheim's estimation of Carroll's personality was based on then-available biographies, the most recent being Florence Becker Lennon's volume chronicling a love life revolving only around little girls and the marriage proposal to

Alice. He refers not only to Langford Reed's "valuable psycho-analytic study" of Carroll's split personality but also to Collingwood's "shadow of disappointment" allusion.[64] The historian corresponded with Lennon on the subject, and through her was put in contact with the estate.[65] On Gernsheim's behalf, Dodgson's nieces had gone through the unpublished diaries, providing him with a redaction of those (and only those) entries specifically mentioning photography. He reproduces a selection of these in the book, a biographical gloss to Carroll's "hobby" that in a way turned the tables on the biographers. Yet the photographs still resided emphatically in the writer's psyche, not his culture.

Carroll's photography—or at least Gernsheim's vision of it—now belonged to photographic history. The monograph's essay need not have belabored a fixation on little girls; the portfolio of photographs provided sufficient fuel for the fire, revealing, even in its relatively cautious edit, an aspect of Carroll's life that seemed to confirm biographers' speculations.[66] When Phyllis Greenacre wanted an example to illustrate her psychoanalytic investigation of 1955, she borrowed from Gernsheim one of the most sensuous (pl. 42), and then revamped his excursus on Caroll's nude photographs (then known about only through mention in the diaries), linking them to his penchant for kissing and other troubling behavior.[67] In 1950 the Museum of Modern Art in New York presented an exhibition devoted to Carroll's photographs, including fifty-nine images and five original albums supplied by Gernsheim and four albums from Princeton University. Again, portraits of children— girls—predominate, and the museum's press release

quotes Gernsheim twice on the matter of possible nude subjects.[68] Edward Steichen, then director of the photography department at the Modern, echoes the Gernsheim view in his wall text for the show: "The bouquet of lovely photographs of children in this collection enriches our appreciation of the unique quality of Lewis Carroll's finely sensitized understanding of children. The author of 'Alice's Adventures in Wonderland' appears in this exhibition as an amateur photographer from back in the days when photography was in its infancy."[69] Gernsheim's book, which served as the catalogue for the exhibition, quickly went into a second edition and was revised and reissued in 1969. This is where an observer like Nabokov would have found the dusty charades that, for him, unmasked Carroll's pathology, and where, for half a century, scholarship on his art remained fixed.

The purpose of rehearsing Carroll's reception into photographic history is not to question its accuracy but merely to demonstrate how the local circumstances surrounding various projects decided their findings, and how these findings then got handed down to later generations and diffused to the public at large. Both Coburn and Gernsheim were practicing photographers; both linked Cameron with Carroll under the umbrella of Victorian amateur practice, as too close an association with the business side of things, in their world, compromised any photographer's petition to be considered a self-expressive artist. Gernsheim, in particular, subscribed to a narrow and dogmatic program for the medium. He was a confirmed modernist, a champion of the straight aesthetic who brooked no manipulation of the photographic subject prior to exposure, and no

retouching or reworking of the image after the exposure was secured. Photography, for him, was about representing the real; contrivance, artificiality, and any attempt to associate the medium with the painterly went against his articles of faith. Consequently, whole sections of Carroll's creative activity emerged as problematic. Gernsheim upbraids Carroll for making double-exposure "ghost" pictures and for having some of his work hand-tinted.[70] Carroll is also admonished for looking to the other preeminent photographers of his day for inspiration:

> *Another aberration in taste was his admiration for the productions of "artist photographers," such as H. P. Robinson, O. G. Rejlander and Lake Price, who in their zeal to raise photography to the status of high art produced a long succession of "imitation paintings"—elaborate compositions on historico-romantic and anecdotal themes such as were particularly beloved by Victorian Academicians, Mulready, Leslie, Augustus Egg and others. If their canvases seem poor to us,* photographic *story-telling is quite ludicrous, on account of the limitations inherent in the photographic medium; yet so ingrained was the Victorian love for this type of subject that even photography—a medium whose sole contribution to art lies in its inimitable realism—was employed to illustrate historical reconstructions and imaginary themes.*[71]

Confronted with the density of fancy-dress and staged pictures that characterize Dodgson's output, Gernsheim must declare them simply a mistake:

> *It goes without saying that most of these costume pictures have to be condemned as errors of taste. Whereas Lewis Carroll's other photographic work shows a remarkable independence of contemporary photography, the sentiment of these pictures is a lamentable concession to Victorian taste. As a producer of costume pictures Lewis Carroll is almost always banal; as a photographer of children he achieves an excellence which in its own way can find no peer.*[72]

He had concluded much the same about Mrs. Cameron, whose performative illustrations of Tennyson's *Idylls of the King* represented an instance of good photography gone wrong. Speaking for his generation, Gernsheim reports: "We have come to realize that photography is a most difficult medium to express imaginative subjects and that most attempts to illustrate the unreal by a medium whose main contribution to art lies in its realism are doomed to failure."[73] In suppressing this aspect of his Victorian artists' production, the historian believed he could make them over as protomodernists and protect them from the debilitating aesthetic norms of the culture in which they operated.

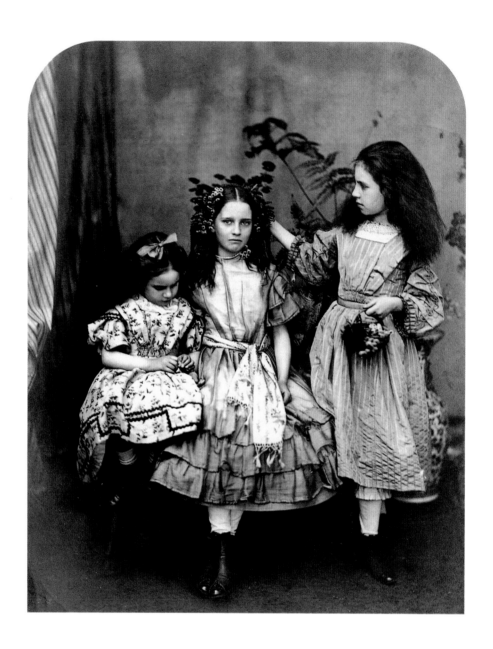

PLATE 4. *Flora Rankin, Irene MacDonald, and Mary Josephine MacDonald at Elm Lodge*, 1863

beauty in the abstract

Our sympathetic engagement with Victorian photography as a whole has not altered fundamentally since the time Gernsheim's books appeared. Although it is true that the contingency of formalism's monolithic value system has been identified in the past few decades, and its medium-specific ratification of photographic objectivity critiqued both in theory and through artistic practice, a modernist bias remains operative: we still view nineteenth-century photography largely through reference to modernism's formulations, even when our aim is to reject them. Looking at reviews of London photographic exhibitions from the 1860s and 1870s, we are struck by the way camera images of tangible, external reality were hung side by side with allegorical, idealizing images staged for the purpose of illustrating stories from literature or art. To the modern viewer, these seem to represent two distinct orders of representation—one about specificity, the phenomenological verification of aspects of the material world, and the other about abstractions, the immaterial, virtual realm of the imagination. Their easy coexistence in

Victorian photographic culture is baffling to us, so conditioned are we to accept the opticality of the former as synonymous with the term "photographic," and so effectively has official history disregarded everything else. To a spectator of the 1860s, however, the later modernist reckoning of photography would itself have appeared puzzlingly arbitrary and philosophically dubious (if even conceivable), and by no means inevitable. To discern what Dodgson's photographs meant to his Victorian milieu, we must embrace the premise that a greater adjacency of the literal and the figurative once existed in the medium, which now looks rather foreign to us.

The *idea* of photography was compelling to Dodgson, as it was to many of his contemporaries. As a twenty-three-year-old scholar, not yet practicing the art, he seized on the newfangled technology to fashion an elaborate metaphor that could satirize prevailing literary styles. "Photography Extraordinary," published in *The Comic Times* in 1855, imagines a photo-based process "applied to the operations of the mind" to beget a labor-saving device for those who write novels. The spoof takes an unwitting young man of the "very weakest possible physical and mental powers," "incapable of anything but sleep," and trains a camera-like mechanism on his person to effect "a mesmeric rapport . . . between the mind of the patient and the object glass."[74] Asked what he is thinking, he replies, "Nothing." The photographic paper is exposed for the appropriate time, then removed. "We found it to be covered with faint and almost illegible characters." A closer inspection nonetheless reveals the following:

The eve was soft and dewy mild; a zephyr whispered in the lofty glade, and a few light drops of rain cooled the thirsty soil. At a slow amble, along the primrose-bordered path rode a gentle-looking and amiable youth, holding a light cane in his delicate hand. . . . With a sweet though feeble voice, he plaintively murmured out the gentle regrets that clouded his breast:

> *"Alas! She would not hear my prayer!*
> *Yet it were rash to tear my hair;*
> *Disfigured, I should be less fair.*

> *"She was unwise, I may say blind;*
> *Once she was lovingly inclined;*
> *Some circumstance has changed her mind."*

The observers remark that such exposition, representative of the "milk-and-water School of Novels,"[75] is utterly unsalable in the present market, and so they apply additional acids to the text, developing it to "the strong minded or Matter-of-Fact School":

The evening was of the ordinary character, barometer at "change," a wind was getting up in the wood, and some rain was beginning to fall; a bad lookout for the farmers. A gentleman approached along the bridle-road, carrying a stout knobbed stick in his hand; and mounted on a serviceable nag, possibly worth some £40 or more. . . . He seemed to be hunting for rhymes in his

head, and at length repeated, in a satisfied tone, the following composition:

*"Well! So my offer was no go!
She might do worse, I told her so;
She was a fool to answer, 'No.'*

*"However things are as they stood;
Nor would I have her if I could;
For there are plenty more as good."*

Satisfied with the progress they are making, the protagonists apply a final treatment to secure a fully intensified example of the "Spasmodic or German School":

The night was wildly tempestuous—a hurricane raved through the murky forest—furious torrents of rain lashed the groaning earth. With a headlong rush—down a precipitous mountain gorge—dashed a mounted horseman armed to the teeth—his horse bounded beneath him at a mad gallop, snorting fire from its distended nostrils as it flew. The rider's knotted brows—rolling eyeballs—and clenched teeth—expressed the intense agony of his mind—weird visions loomed upon his burning brain—while with a mad yell he poured forth the torrent of his boiling passion:

*"Firebrands and daggers! Hope hath fled!
To atoms dash the doubly dead!
My brain is fire—my heart is lead!*

*"Her soul is flint, and what am I?
Scorch'd by her fierce, relentless eye.
Nothingness is my destiny!"*

The patient is thereupon revived to consciousness, and the experimenters conclude that the process could work up William Wordsworth into "strong, sterling poetry," but that application to Byron left the page "scorched and blistered all over with the fiery epithets thus produced." [76]

In the space of four years, Dodgson would return to photography as a literary conceit three more times. He composed a parody of Henry Wadsworth Longfellow's "Song of Hiawatha" in 1857, "Hiawatha's Photographing," and also wrote "The Legend of 'Scotland,'" a Gothic tale set in the fourteenth century, for the daughters of Archbishop Longley. Here "The Ladye's History" section speaks of a "merveillous machine," called a Chimera, which in principal can generate a picture "in a single stroke of Tyme," but which actually takes so long to produce the lady's portrait to her satisfaction that both she and the photographer die waiting and turn to ghosts. [77]

"A Photographer's Day Out," published in 1860, involves "Tubbs," an amateur like Dodgson, summoned by his friend Harry Glover to make portraits of his uncle's family. Enticed by the possibility of meeting Harry's nubile cousin Amelia, he arrives and photographs the father, with his habitual discomfited expression, the mother in costume as her "favourite Shakespearean character," their baby thrashing about, their three daughters in an arrangement falling somewhat short of "a picture of the

three Graces," and a group photo "combining the domestic with the allegorical." The last "was intended to represent the baby being crowned with flowers, by the united efforts of the children, regulated by the advice of the father, under the personal superintendence of the mother; and to combine with this the secondary meaning of 'Victory transferring her laurel crown to Innocence, with Resolution, Independence, Faith, Hope and Charity, assisting in the graceful task, while Wisdom looks benignly on, and smiles approval!'" Predictably, the picture ends in a ruckus, and the photographer winds up his day out being beaten by the locals for trespassing, after Amelia is discovered to be engaged to an army captain.[78]

Taken together, these efforts say something about Dodgson's conception of photography at the beginning of his career. His diaries never venture a word about aesthetics or artistic intentions, nor has he left us anything like actual criticism of photographic works, but these humorous sketches send up certain ideas about the technology that evidently captured his imagination. Latency—the notion that a weak image might be amplified at will—becomes the subject of "Photography Extraordinary," but here the procedure is attempted on a dull-witted clod. The result is a picture, undeveloped though it may be at first, taken directly from his creative intellect—a word picture of interior thoughts, specifically those of a failed romance, which, while unrecognized by their feeble owner, are shown to be, with suitable processing, extremely impassioned. The other three pieces deal primarily with the trials and tribulations of operating a camera and attaining good composi-

tions, but the language and themes all point (in typical Carrollian fashion) to the realm of fantasy. The camera becomes a "chimera"—a figment of the imagination, in other words, mythical in association and better as an idea than in use. Most interesting is Tubbs, whose portrait project moves seamlessly from a character study to a fancy-dress subject to a modern-dress arrangement based on a classical archetype. Dodgson then gently mocks the kind of picture currently popular in photographic circles—the allegorical composition—toward which he himself was gravitating. His description of the various family members personifying symbolic attributes—with the father as Wisdom and the baby at center as Innocence—is highly reminiscent of Rejlander's famed *Two Ways of Life* (fig. 3), which he would have seen at the Manchester Art Treasures Exhibition in 1857. Rejlander's composite, with its troupe of models in different states of undress, depicts a father ushering his two sons into the adult world (overseen by the spirit of their deceased mother) and confronting the choice between rectitude and moral dissipation presented by that world. Rejlander needed a separately published legend to identify all the emblematic figures: Religion, Charity, and Industry, for example, on the one side, illustrating the virtues a young man might follow, with Gambling, Wine, Licentiousness, and other vices arrayed opposite. Near the center was Repentance, accompanied by an effigy of Hope. To us, and perhaps to Dodgson, the didactic, sanctimonious ambitions of Rejlander's magnum opus seem to beg for some deflation, though it must be noted that Prince Albert purchased this particular work for

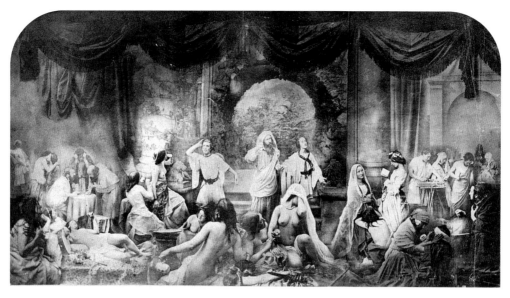

Figure 3. Oscar Gustav Rejlander. *The Two Ways of Life*, 1857. The Royal Photographic Society, Bath, England.

his private collection. "A Photographer's Day Out" derives its humor from the imposition of excessively florid attributes on family members who are, in actuality, common in the extreme.

Rejlander's composition epitomized what Gernsheim considered ill-conceived "imitation painting." Modernist criticism, with its emphasis on style and technique, could only disparage such attempts as violations of the rules. Attention is paid to the style of the work, as if the meaning of the image were immanent there—as if that meaning would be the same for anyone viewing it, at any time. But the question might be posed differently. We might ask what is specifically Victorian about a conception of photography that allows an infant to stand for Innocence and flesh-and-blood children to become the Three Graces. Recognizing this premodern aspect requires attending to not only the work but also its viewer. Lost in the twentieth-century modernization

of the photograph was cognizance of the active role its Victorian observer was expected to play in the creation of its meaning. Photographs that are seen as self-sufficient and materialistic under the modern regime were often deliberately incomplete and quixotic for the Victorians, integers in a synthetic mental operation that could comprehend the simultaneity of the real and the ideal.

This alien mode of viewership can be found operating upon some of the most documentary-seeming of images the period produced. Take the case of Francis Frith's landscape of Mount Horeb (fig. 4). Frith, a Quaker, trekked across the Sinai Peninsula in 1859, intending to follow in the footsteps of Moses and make photographs that might suggest what Frith believed was the historical reality of the incidents narrated in Scripture. Most of these photographs were published in England upon his return, with accompanying texts drafted by the photographer.

Figure 4. Francis Frith. *Mount Horeb, Sinai*, ca. 1857. San Francisco Museum of Modern Art,
Gift of Michael Wilson/The Wilson Center for Photography, 2000.485.N.

Frith thought that Horeb was the Mount Sinai of Exodus, where Moses smote the rock to deliver water to the Israelites, and where the Ten Commandments were received. Frith's image shows what looks to us like a desolate expanse of desert wasteland, with the barren mount in the background and the apparent remnants of a campfire in the foreground. But Frith animates the landscape when he writes:

How great an interest has the scene in which we may look up, as did the Israelites, to the Mount! The place is fit for the solemn event. What a grand simplicity of outline and form, filling the beholder with awe as he stands beneath, and sees the mountain rise heavenward from the plain! How must they have felt who stood here when the mountain it was death to touch burnt with fire, and the terrible sounds and sights shadowed forth the severe justice of the dispensation they announced. . . . Would that we could again mentally people this great plain, and recall the incidents of the stay beneath the Mount. How marvellous must have been the aspect of the desert inhabited by so vast an army—those whose bones were afterwards to whiten its surface!—the noble presence of Moses and Aaron, the strange fickle people, now reverent, now disobedient, one day fearing to be near the Mount, the next making an idol to worship beneath it, while the echoes of the thunders

had scarcely died away. In such views as these we rejoice that neither nature nor man can change the main features of the scene, and thus disturb our efforts to read history by the light of our own impressions.[79]

Frith's narration suggests that his viewers should regard the photograph as akin to a stage set, that they might complete the *mise en scène* by using their imaginations to supply the actors and properties no longer visible and thereby identify with them. This imaginative projection—what Frith calls "reading history by the light of our own impressions"—was predicated on the expectation that members of his literate Victorian audience carried around in their heads Bible stories they had been taught from earliest childhood, mental images based on narrative texts that formed part of a shared cultural language. Such familiarity enabled them to "mentally people the great plain" with their individual conceptions of how the Israelites looked and acted, treating the photographic information as a catalyst that recalled to them an image of the story they remembered. To work, this kind of perception demanded that the viewer entertain an implicit simultaneity; the campfire in the foreground of Frith's picture must exist as both a circle of real Sinai rock and, at the same time, an accessory to an eternally living sacred drama.

Audiences in Dodgson's day could accept the simultaneity of the objective and the subjective in a photograph because they accepted it in life. For the Victorians, typological thinking enacted an everyday Neoplatonism, derived originally from their Protestant theology (which found commonalities in Old Testament and New Testament characters and events) but spilling over into a more universal belief in the "type"—the ideal example or pattern.[80] Richard Owen, the foremost paleontologist in England in the 1850s, could deny the theory that species evolved into other species by suggesting instead that the changes in vertebrate anatomy noticed over time were each to be traced back to one original archetype, God's creative blueprint for all later animals.[81] In the typological scheme, humans are pale reflections of an ultimately invisible and unknowable Divinity: just as Christ was "the word made flesh," so each of us shares tacit attributes of the ideal, as mankind struggles to embody and live out the pattern of God's intended plan, as framed in Scripture. Typology is not exactly allegorical; allegory involves one thing standing for another, whereas typology beholds the individual as the material particularization of a master idea, at once unique and representative. The child is simultaneously herself and an incarnation of Innocence, cohabiting the same body.

Victorian photography of the sort practiced by Dodgson and Cameron is therefore ill-served by the modernist taxonomy that separates their efforts into literal vs. figurative categories. For them—devout Christians both—their subjects lay on a continuum of symbolic meaning, and their task as artists was to negotiate photography's naturalism and deploy accoutrements such as titles to make more or less explicit reference to the spiritual residing within the corporeal. At one end of the scale was the celebrity portrait, where the photographer answered the viewer's expectations

with a map of the subject's outer appearance (and corresponding inner character); at the other end was the emblematic portrayal of abstract ideas, where the proper name of the sitter is irrelevant to the picture's meaning. Across the range, their images depended upon the viewer's having prior experience with the archetypes encoded in their pictures, as well as some faith that not every kind of reality was visible or susceptible to direct representation by photography. The manner of the camera artist, Rejlander argued, was necessarily oblique—to arrange or discover pictorial constructions that distilled the essence of a concept into symbolic form and thus, in his phrase, "render thought visible" to the educated viewer.[82]

Such reliance on the beholder accounts in part for one of the most conspicuous and quizzical stylistic features in the work of Dodgson and Cameron: their crude stagecraft. For most of his portraits, Dodgson was content to move a rug and throw up a cloth backdrop, making little effort to disguise their improvisational look. Wrinkles and folds are visible, and edges often show. The most flagrant example may well be his photograph of Marion Terry, posed in chain mail as James Fitz-James (the hero of Walter Scott's poem *The Lady of the Lake*) outside the Hampstead home of the artist Henry Holiday (pl. 35). While it is true that Dodgson would often trim his compositions after printing, surely by 1875 he could have deleted with his camera the superfluous real estate behind his character (such as a spigot) if he thought it too distracting.[83] In *"St. George and the Dragon"* (pl. 34), the makeshift props adorning the Kitchin children could not be more obvious—a rock-

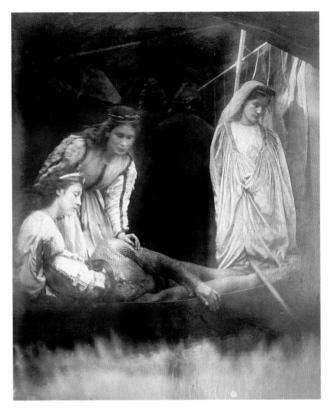

Figure 5. Julia Margaret Cameron. *The Passing of Arthur*, 1875. The J. Paul Getty Museum, Los Angeles.

ing horse suffices for George's steed, the dragon's victim has collapsed on his cardboard shield, and the dragon himself remains a threadbare leopard skin only half concealing the Kitchin boy beneath it. Cameron's tableaux are hardly more convincing. In *Queen Hester* (1865) and *Summer Days* (1866), the chicken wire of her converted studio shows through in the background, and the dramaturgy of her major excursion into photographic narrative—the illustrations to Tennyson's *Idylls of the King and Other Poems* of 1875—in no way transcends the amateur theatricals behind them. *The Passing of King Arthur* (fig. 5) enlists bedsheets for water, a wooden pole for

the mast, and a crescent moon made by scratching into the emulsion with a needle.[84] Cameron and Dodgson could certainly have managed more seamless representations of these episodes if they had so required, but their fancy-subject pictures appear content to give themselves away as the rudimentary play-acted constructions they are.

The Victorian observer may well not have needed anything more. Dodgson's and Cameron's audience, it will be remembered, was quite contained, consisting chiefly of their peers—the most literate group of people in the English-speaking world. As cultured elites, these people read and could recite from memory passages of the Bible, the classics, and their own national literature, from Shakespeare and Milton to the Romantic poets and Tennyson. They also looked at pictures, in museums and galleries and increasingly as reproductive illustrations. Such a viewer needed only a few iconographic markers to recognize the literary subject being depicted. Indeed, guessing the intended subject from schematic props and costumes was exactly the point of *tableaux vivants*—the amateur performances of the day— in which participants don costumes and pose as characters in a picture, as a curtain is drawn back to reveal the scene to its audience. Dodgson's and Cameron's compositions often approximate these theatrical "living pictures" enjoyed by the haute bourgeoisie, where too much detail could even rob the viewer of the special pleasure that came with engaging the subject imaginatively and figuring out its theme.

The concept of imaginative projection precedes the nineteenth century, of course, though it took on a particularly Pre-Raphaelite cast in Dodgson's time. Leonardo records in his notebooks having perceived images in the stains on a wall, a procedure not unlike discovering constellations in the heavens or animal forms in certain clouds. The principle of a picture completed in the mind of the viewer, the *non finito*, made its way to official art theory in the eighteenth century. In *The Elements of Criticism* (1762), Henry Home, Lord Kames, compares the sense of imaginative engagement derived from looking at a good painting with the mental picture conjured up by a strong memory—a sense of virtuality he calls the "ideal presence" of the picture:

> *An important event, by a lively and accurate description, rouses my attention and insensibly transforms me into a spectator: I perceive ideally every incident as passing in my presence; and in idea we perceive persons acting and suffering, precisely as in an original survey. If our sympathy be engaged by the latter, it must also in some measure be engaged by the former.*[85]

Sir Joshua Reynolds, in a 1788 tribute to his recently deceased colleague Thomas Gainsborough, suggests that a painting benefits when the artist avoids excessive detail:

> *Gainsborough's portraits were often little more in regard to finishing or determining the form of the features than what generally attends a dead colour [underpainting];*

but as he attended to the general effect, or whole together, I have often imagined that this unfinished manner contributed even to that striking resemblance for which his portraits are so remarkable. . . . It is presupposed that in this undetermined manner there is the general effect; enough to remind the spectator of the original; the imagination supplies the rest, and perhaps more satisfactorily to himself, if not more exactly, than the artist with all his care could possibly have done.[86]

The silhouette operates according to a similar principle, as does the caricature; minimal diagnostic information activates an ability to fill in missing data and produce the sensation of imagistic completeness. In Dodgson's time, John Ruskin restated the theory of association most cogently. For him, all seeing involved the imagination; perception is founded on the psychological fusion of optical sensation and memory, a synthesis residing in "the power of the imagination in exalting any visible object, by gathering around it, in farther vision, all the facts properly connected with it; this being, as it were, a spiritual or second sight, multiplying the power of enjoyment according to the fullness of the vision."[87] Victorian tableaux like those of Dodgson and Cameron approached the floating literary visions of their audience by way of this "second sight," mediating the photograph's explicitness by including just enough detail to trigger the viewer's imaginative faculties. In this sense, the photograph was like a latent image, worked up in the beholder's mind into something more vigorous. Having lost most of the literary equipment and imaginative discipline the Victorians brought to these pictures, we must accept that our critical perception of them, even with a sincere effort at bridging the historical gap, must end in partial failure. Their insularity—their resistance to meeting our modern expectations—now confers on them something of an artifactual quality, like Minoan frescoes, whose seeming naiveté turns out on examination to be sophistication of an unfamiliar order.

symbolic logic

D odgson first met his idol Alfred Tennyson in 1857, at the beginning of his photographic career. (He gained an introduction by sending a card to Tennyson, reminding him that he was the "artist of 'Agnes Grace'" Weld, the poet's niece, posed as Little Red Riding-Hood.)[88] Dodgson photographed Tennyson's two young sons—"the most beautiful boys of their age I ever saw"—and the father, with whom he enjoyed the first of many interesting conversations. Tennyson once informed Dodgson that after a long day of writing, he sometimes dreamed entire passages of poetry. "You, I suppose, dream photographs," the bard ventured. In a sense, he was right.[89]

Charles Dodgson's photographs adopt as a general theme the otherworldly. As a writer, Dodgson invested himself most fully—and achieved his finest results—in stories about alternate realities. *Alice's Adventures in Wonderland* takes for its premise the creative problem of narrating a dream: the protagonist falls through space, scenes shift without warning, things metamorphose in size or form, and the "nonsense" Carroll is credited with producing is nothing more than a fairly

faithful rendition of the kinds of conversations that happen in our sleep.[90] The tale questions what is normal by specifying alternatives to it: dreaming vs. wakefulness, above ground vs. below, sanity vs. madness, logic vs. illogic, human vs. bestial, and, throughout, childhood vs. adulthood, as Alice asks, "Who am I?" and "Who are you?" through a progression of scenarios. In *Through the Looking-Glass*, the mirror provides the mechanism for contrasting the ordinary world with its reverse, "just the same . . . only the things go the other way." The second story even echoes the first, beginning indoors on a wintry day instead of on a riverbank in July. What is natural is distinguished from what is conventional—the moves on a chessboard, for example, or the rules of language—in the service of a project that places consciousness, materialism, and empirical proof within a richer economy of other possibilities.[91] Fantasy and the power of imagination are key features of this extended mental complex.

Sleep, sleeplessness, attention, and distraction also become ingredients in a number of Dodgson's photographs. Group portraits, such as those of Hugh and Brook Kitchin or the Ellis sisters (pls. 10 and 58), allowed the artist to counterpose reclining and wakeful subjects, their somatic postures indicating internal states. Alice Liddell somewhat improbably dozes fully dressed in the Deanery garden (pl. 24), while Alexandra "Xie" Kitchin, one of Dodgson's favorite later models, is posed in a nightgown for a study he titles *"Sleepless"* (pl. 44). We know that as a young man Dodgson accompanied Reginald Southey to observe a medical operation and was fascinated by

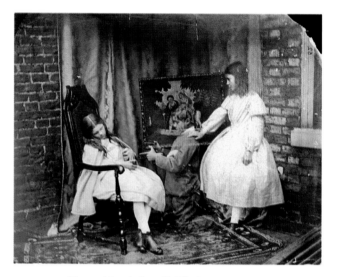

Figure 6. Lewis Carroll. *The Dream*, ca. 1860. The Royal Photographic Society, Bath, England.

the soporific effects of chloroform on the patient.[92] As the author grew older, he suffered from insomnia and in 1893 concocted what he called "Pillow Problems": mathematical or intellectual diversions to "banish those petty troubles and vexations which most people experience, and which—unless the mind is otherwise occupied—*will* persist in invading the hours of night."[93] Sleep, in his writings, was linked to the issue of self-control, dreaming representing a state of complete mental abandon, while wakefulness, too, had its shades of command, including attention and distraction. Several photographs make studied concentration a theme. His friend George MacDonald and his niece Laura Dodgson are caught up in their books; Ella Monier-Williams and her brother stare intently at dolls; Julia Arnold contemplates a mirror; and the sculptor Alexander Munro and his wife gaze intently at each other. (pls. 16, 75, 29, 47, and 7).

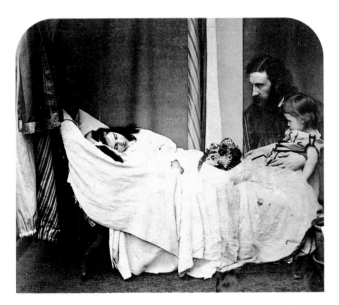

Figure 7. Lewis Carroll. *Mary MacDonald Dreaming of Her Father and Brother*, 1863. National Galleries of Scotland.

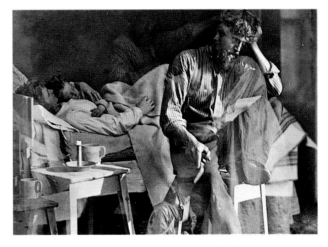

Figure 8. Oscar Gustav Rejlander. *Hard Times*, 1860. Courtesy George Eastman House.

Complementary to these are models found in an attitude of reverie, such as Annie Coates or Lizzie Wilson Todd (pls. 22 and 64), or of languid introspection, as with Margaret Langton Clarke (pl. 17) and Dodgson himself in his 1875 self-portrait (pl. 1). The artist admitted to the expediency of having restive young subjects feign sleep during his long exposures, but his obvious success with wakeful specimens establishes that he did not need to rely on it.

The idea of photographing a dream or any other interior event may strike us as somewhat fabulous, but it represents another instance of Dodgson's preoccupations making their way into both his literature and his pictures. He points to the condition with the title of one study of Xie Kitchin, *"Rosy Dreams and Slumbers Light"* (pl. 43)—a line taken from Scott—sometimes also called *"Where Dreamful Fancies Dwell."* Either title makes it clear that this

photograph has less to do with sleep than it does with the imaginative activity of the sleeper. *The Dream* (fig. 6) goes one step farther, using a double-exposure arrangement to portray both the dreamer and the dream. Here the Barry children act out a composite Nativity: the sleeping virgin on the left has a vision of the Magi (her brother and sister) bearing gifts, while behind them a painting depicting the Flight into Egypt indicates a later episode in the narrative. An unusual combination print by Dodgson has Mary MacDonald dreaming of her father and brother, who watch over her vulnerable form (fig. 7), her inner awareness contrasted with their attentive outward focus. Oscar Rejlander had demonstrated the expressive potential of this invention in 1860 with his *Hard Times*, in which the worried laborer appears in spectral form to his sleeping wife and child (fig. 8). Rejlander referred to this as "A Spiritistical Photo."[94]

Dodgson seems to have been superstitious by nature. He had a favorite number (42) and a lucky day (Tuesday) and was open-minded about the possibility of telepathy and paranormal events. He was a charter member of a spiritualist group known as the Society for Psychical Research and enlisted in the Ghost Society.[95] Spiritualists believed in necromancy—communication with the dead—and Dodgson joined other prominent Englishmen, including William Gladstone, Arthur Conan Doyle, Frederic Leighton, Tennyson, Ruskin, and G. F. Watts, in advocating the systematic investigation of supernatural happenings. In a letter to his friend James Langton Clarke (pl. 15) in 1882 he describes table-rapping, thought-reading, and other psychic phenomena as credible and disparages "scientific skeptics, who always shut their eyes, till the last moment, to any evidence that seems to point beyond materialism."[96] Whether he actually believed in the existence of fairies is unclear, but he was not averse to encouraging children to believe in them. He copied Daniel Maclise's painting *Undine* (1843) for one of his photographic albums, and in 1857 he took the time to count all 167 fairies in Joseph Noel Paton's Shakespearean *Quarrel of Oberon and Titania*.[97] Fairy painting was a popular genre in Victorian England; artists such as John Anster Fitzgerald, in *The Artist's Dream* (1857), *The Nightmare* (ca. 1857–58), and *The Stuff That Dreams are Made Of* (1858), used the motif of the dreamer (in something like the semi-conscious "eerie state" described in Carroll's 1889 book *Sylvie and Bruno*) visited by apparitions of elves, fairies, and goblins.[98] Dodgson believed in miracles and the afterlife and

reveals the Christian Neoplatonism that underlay his faith in a reply to a correspondent in 1882: "I find that as life slips away (I am over fifty now), and the life on the other side of the great river becomes more and more of a reality, of which this is only a shadow, that the petty distinctions of the many creeds of Christendom tend to slip away."[99] Earthly existence, like the shadows on the wall of Plato's cave, was for him but a visible manifestation of the spirit that resided within.

Dodgson's vocation as a mathematician was in no way incompatible with the rest of his mental universe. Indeed, the Euclidean precepts to which he adhered enact the purest form of rational Platonism one might imagine. Mathematics begins as a description of the real world but ends as an extrasensory model of reality in the abstract, charting the otherwise unknowable with conventions that operate autonomously before the mind's eye. Galileo once referred to mathematics as "the language of Nature," the implication being that God's creation is encoded with harmonies and relationships best expressed through the law of numbers. Geometry was Dodgson's area of specialization; its métier is to delineate and verify perfect forms by advancing logically through a series of axioms. His professional writings on the subject—*Euclid and His Modern Rivals*, for example, or his work on determinants and on proportional representation—were not considered as theoretically ground-breaking in their own day as they are now, as Dodgson's real talent lay in popularizing mathematical reasoning and formal deduction, through puzzles and syllogisms, such as those presented

in the *Alice* books and in his 1886 *Game of Logic* and the 1895 *Symbolic Logic*. The "mental recreations" presented in the latter begin with the concept of "classification," accordingly, where the text encourages readers to embrace idealist thinking:

> *"Classification," or the formation of Classes, is a Mental Process, in which we imagine that we have put together, in a group, certain Things. Such a group is called a "Class."* . . . *As this process is entirely* Mental, *we can perform it whether there* is, *or is not, an* existing *Thing which possesses that Adjunct. If there* is, *the Class is said to be "Real"; if* not, *it is said to be "Unreal" or "Imaginary." For example, we may imagine that we have picked out, from the Class "Things," all the Things which possess the Adjunct "material, artificial, consisting of houses and streets"; and we may thus form the Real Class "Towns."* . . . *Again, we may imagine that we have picked out all the Things which possess the Adjunct "weighing a ton, easily lifted by a baby"; and we may thus form the* Imaginary *Class "Things that weigh a ton and are easily lifted by a baby."*[100]

Geometry's codification of the universe's infinite possibilities into ordered patterns and combinations through axiomatic rules and protocols can be found in another mental recreation close to Dodgson's heart: the game of chess. Like the situational logic of the

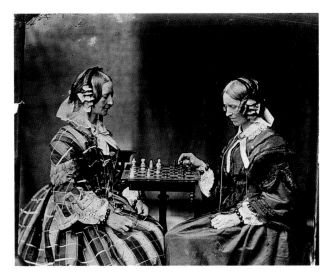

Figure 9. Lewis Carroll. *The Misses Lutwidge Playing Chess*, ca. 1858. National Museum of Photography, Film, and Television, Bradford, England.

syllogism, chess involves bilateral divisions as its premise (two, in fact: the light and dark opponents in one orientation, and the reverse alignment of men on either side of the King and Queen), and the progress of the game can be thought of in terms of "eliminands" and "retinends": pieces eliminated or retained to the end. Both are mapped out on a geometric grid, and movement is numerically annotated. The sustained chess moves of *Through the Looking-Glass*, which ends only when Alice checkmates the Red King, is the perfect motif for the story not only because it continues the binary logic of the mirror world postulated, but also because it picks up the social subtext of identity through power and position (from pawn to royalty) of the playing cards in *Alice's Adventures in Wonderland*.[101] In an early photograph (fig. 9), Dodgson contrives to put his identical-looking maternal aunts, Margaret Anne and Henrietta May

Lutwidge, on opposing sides of a chessboard. The backdrop is divided vertically into black and white domains, countering Henrietta, in dark dress and playing the dark pieces, with her sister, playing white, and wearing a lighter dress that is "checked." Dodgson would go on to make other photographs of chess-playing families, notably the Rossettis, absorbed in geometrical conflict that metaphorically suggests the strategy and drama inherent in a simulated social existence dictated by rules, hierarchies, and conventions.

In venturing to make photographs more directly drawn from the imagination, Dodgson found another helpful model in the theater. The stage was a passion for him second only to photography; his diaries record his attendance at innumerable performances and a personal acquaintance with actors and actresses of all ages. His devotion to the theater began at an early age and continued beyond what might be expected of a cloistered don. Despite the fact that his writings on the subject indicate he was something of a prude when it came to what he deemed a proper dramatic subject, there is no doubt that his playgoing, in principle, was disapproved of by his High Church father and by Bishop Wilberforce of Oxford.[102] In Dodgson's mind, the theater had the potential to fire the imagination by engaging the audience sympathetically in its action. He therefore spent considerable energy trying to reform, rather than abandon, the institution in order to make it suitable for the many young guests who would accompany him to performances.[103] An article he published titled "The Stage and the Spirit of Reverence" speaks to the power of drama to elicit the better part of human charity:

Years ago I saw Mr Emery play the hero of "All is not Gold that Glitters"—a factory owner, with a rough manner but a tender heart; and I well remember how he "brought down the house," when speaking of the "hands" employed in his factory, with the words, "and a' couldn't lie down and sleep in peace, if a' thowt there was a man, woman, or child among 'em as was going to bed cold and hungry!" What mattered it to us that all this was fiction? That the "hands," so tenderly cared for, were creatures of a dream? We were not "reverencing" that actor only, but every man, in every age, that has ever taken loving thought for those around him, that ever "hath given his bread to the hungry, and hath covered the naked with a garment."[104]

As a twenty-three-year-old novice, Dodgson attended a memorable production of Shakespeare at the Princess' Theatre in London. He describes its effect on him with exceptional detail in his diary:

. . . And then came the great play, Henry VIII, *the greatest theatrical treat I ever had or expect to have. I had no idea that anything so superb as the scenery and dresses was ever to be seen on the stage. Kean was magnificent as Cardinal Wolsey, Mrs. Kean a worthy successor to Mrs. Siddons in Queen Catherine, and all the accessories without exception were good—but oh, that exquisite vision of*

Figure 10. *Queen Catherine's Dream*, from *Illustrated London News*, 1855.

Queen Catherine! I almost held my breath to watch: the illusion was perfect, and I felt as if in a dream all the time it lasted. It was like a delicious reverie, or the most beautiful poetry. This is the true end and object of acting— to raise the mind above itself, and out of its petty everyday cares—never shall I forget that wonderful evening, that exquisite vision—sunbeams broke in through the roof, and gradually revealed two angel forms, floating in front of the carved work on the ceiling: the column of sunbeams shone down upon the sleeping queen, and gradually down it floated a troop of angelic forms, transparent, and carrying palm branches in their hands: they waved these over the sleeping queen, with oh! such a sad and solemn grace. So could I fancy (if the thought be not profane) would real angels seem to our mortal vision, though doubtless our conception is poor and mean to the reality.[105]

An engraving in the *Illustrated London News* (fig. 10) gives a sense of what so moved him; Dodgson, as Diane Waggoner has observed, understood the play in emphatically visual terms, describing it as he would a picture or a tableau vivant. His reaction to it at this early date, just before taking up photography, suggests how it might have become one kind of prototype for the theatrical costume pieces he would soon be constructing for his camera—more particularly, how the suspension of disbelief he experienced might have become one artistic goal. He describes other performances in this way—"The whole scene was a picture not to be forgotten," "one of the most beautiful living pictures I ever saw"[107]—and in fact could detect when a painter had used the stage as a source of imagery.[108] As *Henry VIII* had demonstrated

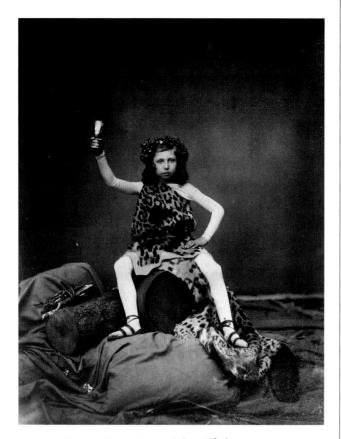

Figure 11. Roger Fenton. *Prince Alfred as Autumn, Windsor Castle*, 1854. Royal Archives, Windsor Castle.

The tableau vivant gained popularity at the highest levels of society. Roger Fenton, for example, made a series of photographs in 1854 showing Queen Victoria's children acting out James Thomson's epic poem *The Seasons* (1726–44; fig. 11). Cameron staged such theatrical pictures at her home on the Isle of Wight; Dodgson writes of attending tableau performances put on by the Liddell girls at the Deanery and wanting to restage them for his camera.[109] His photographs of St. George (pl. 34), of the professional Terrys as Cinderella, Fitz-James, and Andromeda (pls. 18, 19, 35, and 36), Xie Kitchin as a Tea Merchant, a Dane, or a Greek (pls. 45, 46, 49, and 52) all approximate the amateur performances that were familiar to his models as well as the viewers of his results, right down to the homespun staging. Costumed tableaux were like a domestic version of the fancy-dress ball, which replaced the masquerade as an aristocratic social event in the Victorian age. Some of Dodgson's contemporaries, such as David Wilkie Wynfield, specialized in posing prominent sitters in costumes of the Tudor or Elizabethan period (fig. 12) that would have been worn to such balls.[110]

In 1872 Dodgson wrote a script for Beatrice and Ethel Hatch (pl. 71), the daughters of Dr. Edwin Hatch, vice-principal of St. Mary's Hall, Oxford. This piece, intended for home performance, includes a clever prologue, which reads in part:

> *My gentle censors, let me roundly ask,*
> *Do none but actors ever wear a mask?*
> *Or have we reached at last that golden age*
> *That finds deception only on the Stage?*

to him, the theater allowed otherworldly visions—dreams of angels on sunbeams—to be given a concrete reality impossible to represent elsewhere, with the power to move the soul.

Theatricality was a hallmark of Victorian visual culture. It informed the narrative painting popular at the time (especially that of the Pre-Raphaelites) and the practice of other photographers, including Cameron, Lady Hawarden, Rejlander, and Robinson. Amateur theatricals became something of a craze in the second half of the nineteenth century, as fashionable families staged domestic versions of dramas and classic literary scenes for their private enjoyment.

Come, let's confess all round before we budge,
When all are guilty, none should play the Judge.
We're actors all, a motley company,
Some on the Stage, and others—on the sly.[111]

The trope is a venerable one—each of us is an actor on the world's stage, strutting and fretting our hour in costume and prescribed role—but it coincides with Dodgson's Platonic grasp of reality and his personal meditations on identity. He was highly conscious of the roles he played for others—his family and friends, his students and academic colleagues, the readers of his books. He was also clearly a deeply pious man, not always doctrinaire on religious matters but inarguably reverent and a true believer in revelation. His diaries are filled with prayers and beseeching for heavenly guidance, the sincere pleadings of a man trying to meet the highest standards for a Christian life in service to others. The physical world was, for Dodgson, a scaffolding for another reality not visible to human eyes. His investment in the invisible, the impalpable, and the unknowable was an integral aspect of his theology, for God and heaven, as Kant had explained, are beyond the senses, cannot be certified, must be taken on faith. The alternate realities he playfully deployed—of dreams, phantasms, fairy worlds, trances and visionary states, mathematical and logical abstraction, scenes of the imagination—are part of a spiritual project that supports the ultimate alternate reality: the existence of God, of heaven, angels, and the afterlife. Feelings, beliefs, faith, and visions were as real for him as steamships and top hats, but their representation in

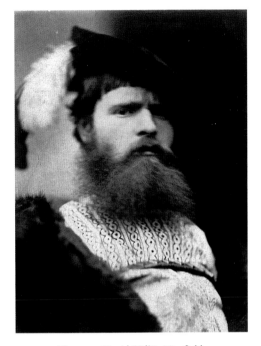

Figure 12. David Wilkie Wynfield.
Portrait of William F. Yeames, 1860–65.
The J. Paul Getty Museum, Los Angeles.

photographs needed a language like those worked out in other cultural forms—the theater, for instance, or painting—where immaterial concepts might be given proximate visual expression. Transcendental idealism speaks to the unknowable through metaphors and allegories; the artist (or the cleric, for that matter) depends on them for relating the metaphysical to the empirical in understandable terms. In the Dormouse's story, its narcoleptic narrator requires the three little sisters to sketch both real things and abstractions: "mouse-traps, and the moon, and memory, and muchness."[112] Dodgson's photography operated in a world where migration from one classification to the other was not as unmanageable as it would later become, where real and unreal as yet coexist equally as a set of potential pictures available to the artistic imagination.

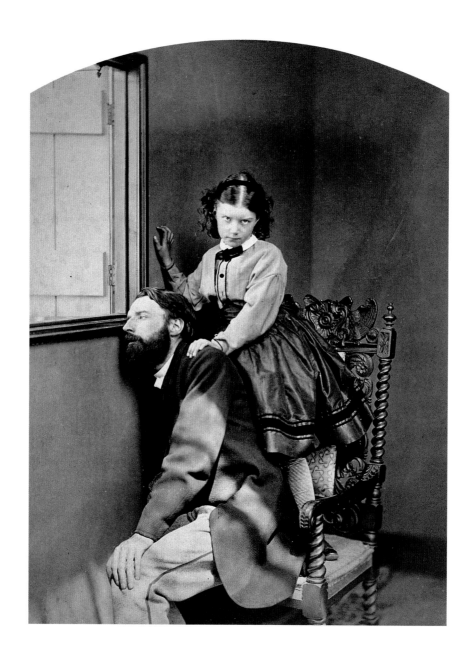

PLATE 5. *Rev. Thomas Childe Barker and His Daughter May*, 1864

ducks that die in tempests

<center>❖</center>

ecognizing his creative works to be highly individualistic enunciations of ambient cultural concerns, and that Dodgson, as a representative Victorian, could in theory entertain a simultaneity of the ideal and the real, we might here venture the proposition that, as a photographic subject, children were not of particular interest to him. In life, he certainly sought and usually enjoyed their company, and his diaries catalogue an endless roll call of acquaintances established, maintained, or abandoned, but an examination of Dodgson's camera work reveals something oddly impersonal about his photographic project. In sum, he was more engaged with the concept of childhood than he was with the individuality of children. His young sitters are not so much recorded being children as they are made to play at being children.

Part of our interpretive difficulty with these images no doubt stems from our submerged awareness that this is, in fact, the case, and that childhood, as a condition, is a historically unstable (and currently highly destabilized) category. The infant, the toddler, the schoolchild, the adolescent,

and the teenager are social designations, not biological ones. They denote levels of social competence and integration into the adult order, a set of differentiations that did not exist a few centuries ago but have evolved and mutated rapidly in the modern era. In Western culture today, children drink, smoke, use drugs, commit adult crimes, and become sexually active at increasingly younger ages. We lament the disappearance of childhood but nonetheless abide commercial images that encourage young people to desire adult clothing and cosmetics as quickly as possible, and that sexualize young bodies in an effort to sell expensive products to this newly discovered market sector. The improvised playground game of yore has given way to organized league sports, under adult management and on the professional plan, and childhood friendships are now conducted on an appointment basis. All the while adults get infantilized; off-road vehicles are sold as if they were large toys, and the fashion industry co-opts the onetime informality of children's wear as the newest adult styles. The entertainment industry and electronic media are at the apex of this convergence. Language and situations unimaginable as recreation a few decades ago are now routinely piped into every home through a proliferation of channels, with the degree of moral complexity in purportedly adult dramas pitched at a level scarcely beyond the comprehension of the average eight-year-old.[113] The social distinctions between "adult" and "child," once founded on certain kinds of knowledge and privileges allowed the former and withheld from the latter, are becoming extinct, despite sincere attempts by many to stave off this inexorable historical trend.

The notion of childhood as a separate, protected phase of life did not exist in the Middle Ages, however. For much of Western history, "child" expressed only blood relation, not age. Children were generally regarded as underdeveloped adults, categorically undifferentiated, who mixed in adult society as soon as they were able to speak. Indeed, the Catholic Church held congregants responsible for distinguishing between good and evil—the "age of reason"—when they reached their seventh year. Prior to the Renaissance, paintings show youngsters wearing the same clothing styles as adults and routinely witnessing an adult world that included drunkenness and overt licentious behavior. Physical interaction with children, including sexual contact, was accepted as a commonplace, considered merely "ribald" activity.[114]

Interestingly, it was the arrival of the printing press in fifteenth-century Europe that helped establish the social conditions for modern childhood. If in medieval times a child entered society as soon as he or she could speak and understand what was being said, the emerging print culture of the Renaissance adopted literacy as a standard of acceptance into adulthood. Thus schooling became a necessary institution for imparting the skills required for social proficiency, which led to the emergence of the now-familiar system of consecutive grades or forms. Childhood was increasingly articulated in relation to the mastery of progressively complex varieties of knowledge—abstract knowledge—which, because it came from books, could be administered by adults and meted out at age-appropriate intervals. It followed that the perceived contrast between "adult"

and "child" would grow, as more and more children were taken out of the home and the workplace and sequestered together in a facility that upheld their separateness. Such differentiation, along with factors such as high infant-mortality rates, encouraged the perception of the child as representing a kind of ideal, inhabiting a body categorically different from the adult's. This outlook became marked in the eighteenth century, reached its apogee in Charles Dodgson's time, and has been observing a bumpy decline ever since.

The Victorian "cult of the child," designated as such by its Victorian adherents, built upon Jean-Jacques Rousseau's idea that the child approaches the world in a way fundamentally dissimilar from that of adults and should be celebrated for doing so.[115] To his mind, the child, like the noble savage, more nearly approximated a "state of nature," as yet unaffected by the corrupting effects of civilized values, than did the grown-up. The child demonstrated impulses that should be embraced, such as spontaneity, curiosity, candor, and a capacity to experience unqualified joy, which led Romantics, such as Wordsworth and William Blake, to regard adults as "fallen children" and to consecrate the innocence and naturalness of the child in their poetry. In this view it is the adult who has the problem; with their memoirs, Wordsworth, Ruskin, and a host of other writers present childhood as an Edenic state of happiness, and adulthood as the expulsion from its garden. Art, for them, became the project of returning (however we may) to that condition of openness and wonder lost in the process of maturation and enculturation.[117]

Ideal childhood thus existed in opposition to the diminished state of adulthood and might therefore be seen in connection with that other ambient Victorian binary, gender. In the urbanized world of the nineteenth century, polite women and children were conceptualized together as occupying a discrete domestic sphere. For the middle class, the market economies in the late eighteenth century entailed a new approach to thinking about the family; domesticity was consecrated, the home became the reigning symbol of security, and women became its centerpiece. The bourgeois announced his status through his ability to keep dependents unemployed at home. Women not only bore children but were presumed to be in many ways ideally childlike themselves—in their delicacy, sensitivity, weaker physical strength, and (it was thought) their relatively limited intellectual competence. The domestic sphere operated through a moral division of labor: men went out into the grubby world of money-making and sin, and were necessarily compromised by contact with worldly pursuits, whereas women and children, sequestered within the walls of the home, could remain the conscience and moral compass of the family, both the impetus for manly effort and an antidote to its transgressions. *The Angel in the House*, Coventry Patmore's popular 1854 ode to wifely excellence, characteristically cast man's "better half" in the anodyne role by making her helpless:

> *She grows*
> *More infantine, auroral, mild,*
> *And still the more she lives and knows*
> *The lovelier she's expressed as child.*[118]

As the repository of the family's morality, the domestic sphere required its women and children to be sheltered, passive, and emblematic. The asset most worthy of protection was their innocence. The spiritually redemptive power of female virtue was so prized that Victorian handbooks often instructed women to be childlike in their sexuality as well, to appear uninterested in it, to view it as properly belonging to the male sphere of worldly corruption. The "pure" woman was expected to be self-denying here, as everywhere else. John Ruskin neatly summarized this moral mitosis in *Sesame and Lilies* (1865):

> The man's power is active, progressive, defensive. He is eminently the doer, the creator, the discoverer, the defender. His intellect is for speculation and invention; his energy for adventure, for war, and for conquest. . . . But the woman's power is for rule, not for battle,—and her intellect is not for invention or creation, but for sweet ordering, arrangement and decision. . . . Her great function is Praise. . . . By her office and place, she is protected from all danger and temptation. The man, in his rough work in the open world, must encounter all peril and trial:—to him, therefore, the failure, the offence, the inevitable error: often he must be wounded, or subdued, often misled, and always hardened. But he guards the woman from all this; within his house . . . need enter no danger, no temptation, no cause of error or

offence. This is the true nature of home—it is the place of Peace; the shelter, not only from all injury, but from all terror, doubt, and division. . . . So far as it is a sacred place, a vestal temple, a temple of the hearth watched over by Household Gods, . . . it vindicates the name, and fulfills the praise, of home. And wherever a true wife comes, this home is always around her. . . . She must be enduringly, incorruptibly good; instinctively, infallibly wise—wise, not for self-development, but for self-renunciation: wise, not that she may set herself above her husband, but that she may never fail from his side: wise—not with the narrowness of insolent and loveless pride, but the passionate gentleness of an infinitely variable, because infinitely applicable, modesty of service—the true changefulness of woman.[120]

The cult of the child was therefore intimately related to the cult of the woman; both the child and the household Madonna shared a pedestal that sustained their special symbolic status as moral paragons. The photographers Julia Margaret Cameron and Charles Dodgson, like the Pre-Raphaelite painters who were their peers, made these twin cults the vital center of their imagery. Cameron's maidens were assigned the appropriate saintly traits through titles like *Goodness*, *Meekness*, *Long Suffering*, and *Devotion*, and for the same reason she chose to illustrate Old Testament characters like Rachel, or modern ones like Henry Taylor's Rosalba—model women who

sacrificed their needs to those of their men. Dodgson evidently subscribed to this view, expressing admiration for Patmore's poem, for instance, and often counseled young female friends to approach marriage as the most sacred of religious institutions.[121] After his father's death in 1868, and by then secure in his place in the larger world, Dodgson became for all intents and purposes the family patriarch, the titular mainstay of his surviving aunts and six unwed sisters, whom he moved to closer proximity in Guildford. He believed in the conventional masculine role assigned him by the times and his training, and despite official bachelor standing, he lived it out, sheltering these female relatives from most contact with the outside world. His familial role, which he took seriously his entire life, was to protect the weak and vulnerable.

A number of Dodgson's photographs use children to enact the gender placements into which proper Victorian society expected its youngest members to grow. Boys, when they reached the appropriate age, were sent away to school, Dodgson's own Rugby being merely the most prestigious. Here they learned not only the academic subjects that would serve them at university but also instruction in character: the manly skills of good sportsmanship, generosity, courage, discipline, and self-reliance, which would prepare them to be future citizens and world leaders. Preparatory school represented the interim removal of the boy from the feminized domestic sphere to a masculine enclave of headmasters, prefects, and residential houses, made famous by Thomas Hughes's reminiscences in his 1857 bestseller *Tom Brown's School Days*.[122] Harry Liddell, posed with his three

sisters, is displayed as already part of this system (pl. 25). A student at Twyford School in 1860, under the jurisdiction of Dodgson's former Christ Church companion George William Kitchin, Harry holds a cricket bat as his attribute, which stands out amid the girls, whose outdoor equipment remains their summer hats and frocks. In two different sittings with Annie Rogers and her brother Henry (pls. 30 and 31), Dodgson shows the boy holding a toy gun, improbably large in the earlier of the two images. Wickliffe Taylor clutches a sword (pl. 63), and the young Charles Langton Clarke appears to be handed a long-barreled pistol by his father (pl. 15). The Carroll myth purports the author's apathy toward or even aversion to male children in both art and life, but to say he disliked boys we would need to willfully ignore the character of Bruno, whom he developed sympathetically over the period from 1867 to 1893 (longer than his investment in Alice), and disregard as well those passages in his diaries that comment quite unaffectedly on the beauty and appeal of worthy boys.[123] His photographs also testify to a thoughtful deliberation over the pictorial problem of representing boyhood as a distinct subcategory of childhood.[124] Their weapons emblematically prefigure their duty as men of honor, as the prospective officers and athletes in society's great contests—"the doer, the creator, the discoverer, the defender," in Ruskin's overwrought phrase.

In contrast, girls are often posed in adumbrations of female virtues. The well-bred Victorian girl learned quickly that she must refine her creative talents for music, drawing, conversation, dancing,

and perhaps foreign languages, and cultivate her physical beauty, so as to prepare her for courtship and marriage and the social responsibilities entailed by it. In playful stagings of such female roles, Dodgson has Julia Arnold contemplate her attractiveness in *"Little Vanity"* (pl. 47) and Irene MacDonald struggle with unruly hair at her morning toilet, in a variant of a work he titles *"It Won't Come Smooth"* (pl. 69). Xie Kitchin appears with her violin, Effie Millais with her drawing slate, and a number of girls, including Ella Monier-Williams and Charlotte Denman, are shown attending to dolls (pls. 50, 61, 29, and 72). These images present girls as women-in-training, destined to assume their own gender-prescribed social roles as mothers and wives.

Dodgson's 1863 group portrait of Flora Rankin, attended by Irene and Mary MacDonald (pl. 4), further illustrates his engagement with the idea. Flora is posed as the May Queen, receiving a crown of what would be hawthorn (or "may") blossoms from Mary, reenacting a pagan English custom that goes back to the time of the Druids. May Day marked the beginning of summer, and as part of the festival's celebration of fertility, townsfolk decked their homes with hawthorn, the herbalists' potency tonic, after "bringing home the may." [125] The twisted ribbons of the May pole signified sexual union, and the holiday culminates in the selection of the Queen of the May, the community's fairest girl, who wears a headdress of flowers as she leads the procession through town. The May Queen character was therefore associated in English lore with rites of passage into adulthood; indeed, the Puritans banned the custom in 1644

because so many young women returned home from the celebrations pregnant. Dodgson's tableau, centered on the aptly named Flora, doubtless alludes to Tennyson's ballad "The May Queen," illustrated by J. C. Horsley in the deluxe 1857 Moxon edition of his collected poems (fig. 13). In Tennyson's telling, the cruel-hearted belle who narrates it revels in the romantic opportunities resulting from her nomination, as she rejects the intentions of the admiring Robin:

> *They say he's dying all for love, but that can*
> * never be:*
> *They say his heart is breaking, mother—*
> * what is that to me?*
> *There's many a bolder lad 'ill woo me any*
> * summer day,*
> *And I'm to be Queen o' the May, mother,*
> *I'm to be Queen o' the May.* [126]

What distinguishes Dodgson's rendition from Tennyson's, Horsley's, or even Mrs. Cameron's later treatment of the same subject is that the girls in his enactment are clearly pre-adolescent, Mary, the tallest, being only ten at the time of the session. The girls are made to play at a ritual they are too young to understand or participate in, theirs being an affected sexual power brandished naively, like their brothers' sham weapons, in unconscious underage rehearsal.

The capacity of tableau photography to articulate gender roles, especially by reversing them, is something Dodgson admired in the work of his contemporary Clementina, Lady Hawarden. Hawarden specialized in costume studies of her mature daugh-

Figure 13. J. C. Horsley. *The May Queen*,
from Alfred Tennyson, *Poems* (London: Edward Moxon, 1857).

ters, posed in and around the drawing room of their
South Kensington townhouse. Dodgson discovered
her work in a Photographic Society exhibition on 23
June 1864 and called on her at home, only to learn
that her husband had been a student of his father's.
He soon took Mary and Irene MacDonald by to be
photographed by Hawarden and purchased five of her
distinctive studies for himself.[127] Hawarden's scenarios
involved fancy dress, and in several cases one or the
other of the daughters would don breeches and pin up
her hair in order to play the male role in a scene—the
serenading gallant or a visiting courtier, for example.

The viscountess's unexpected death in January
1865 left the field to Dodgson, however. He cast
Ellen Terry in the role of Perseus, to sister Kate's

Andromeda (pl. 36), Ethel Hatch and Florence Terry
as male Turks (pl. 37), and Xie Kitchen as a Chinese
(pls. 45 and 46). In many of the theatrical produc-
tions he frequented, this kind of cross-dressing was
an accepted trope—Rosalind, in *As You Like It*, or
Viola, in *Twelfth Night*, disguise themselves in male
costume—so Victorian propriety would have sanc-
tioned Dodgson's photographic efforts in this vein.
When the actress Marion Terry appears in chain mail
as Fitz-James (pl. 35), educated Victorians would
have appreciated this as an essay in imposture. In
Scott's poem Fitz-James is none other than the
English king James V, disguised as a lone knight to
penetrate the Highland domain of his enemy, the clan
lord Roderick Dhu.[128] While undercover he becomes
lost but is aided by Ellen, the daughter of the outlaw
Lord James of Douglas, and falls in love. He van-
quishes Roderick in a bloody sword fight and
reclaims the country. As the Saxon hero in Dodgson's
photograph, Terry resembles the long-haired youth
who slays the Jabberwock in Tenniel's illustration
for the second *Alice* story (fig. 14), yet ironically, the
photograph was made at the Hampstead residence of
Henry Holiday, the artist Dodgson had enlisted in
1874 to illustrate his backwards poem "The Hunting
of the Snark."[129] Scott's romance, less ambiguously
than Carroll's, emphasizes the single-minded valor
and decency of the English king, manly qualities
called all the more to attention here by their embodi-
ment in the noticeably curvaceous actress.

Imposture and ironic contrast are leitmotifs
running through many of Dodgson's more sophisti-
cated photographs, just as they are important elements

Figure 14. John Tenniel. *Slaying the Jabberwock*,
from Lewis Carroll, *Through the Looking-Glass*
(London: Macmillan, 1872).

in his stories. In perhaps his most well-known image, he has Alice Liddell pose as a beggar-maid, clothes tattered and hand extended as she petitions us for alms (pl. 21). This is one of several studies he made of Alice and other girls as beggar-children, a popular Dickensian subject that Rejlander treated photographically in his acclaimed *Poor Joe*, also titled *Homeless* or *A Night in Town* (fig. 15).[130] Like the crossing sweepers and bootblacks he also posed in his studio (prints of which Dodgson owned), Rejlander's child is a "street type," whose bare feet, bedraggled garments, and pathetic attempt to sleep on a doorstep tacitly

indicate a recognized social-reform issue. Dodgson's mendicant is given all the appropriate iconographic markers, and indeed the photograph is one of a pair, arranged the same day at the Deanery; Alice is shown as both a proper girl in her finest dress and as a pauper— the kind of before-and-after reversal of social roles romanticized by the Victorians.[131] Of course, neither Dodgson nor Rejlander would have felt it appropriate to use real street children as their subjects. Good taste (and, in Dodgson's case, an overdeveloped sensitivity to actual class difference) demanded that the viewer understand these were unendangered child-models, posed as types. Tennyson reportedly declared *Alice Liddell as "The Beggar-Maid"* the most beautiful photograph he had ever seen, so effective was it in its own day at modulating social sentiment through the filter of costume and child's play.[132] It is a venerable strategy; many of our own concerns about poverty are approached rhetorically by appealing to its effect on innocent children.

Dodgson returns to the theme in a variety of ways. In July 1864 he was on hand for an evening performance of *Cinderella* at the home of George MacDonald, with his daughter Mary in the title role, Lily and a friend as the stepsisters, and Grace as the fairy godmother.[133] He photographed the young Florence Terry as Cinderella (pls. 18 and 19) the next year, one scene showing her in the scullery, peeling vegetables and awaiting the arrival of the prince, her bare foot perched upon a plinth. Again, the fairy tale is a rags-to-riches allegory of fortitude rewarded. His portrait of Xie Kitchin as Penelope Boothby (pl. 9) evokes the story of Sir Brooke Boothby, the

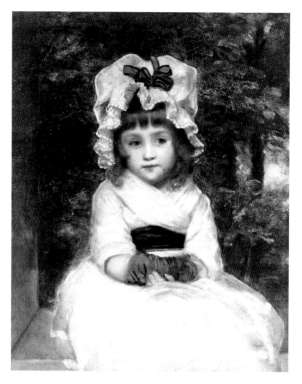

Figure 15. Oscar Gustav Rejlander. *Homeless*, ca. 1860.
Courtesy George Eastman House.

Figure 16. Joshua Reynolds. *Portrait of Penelope Boothby*, 1788.
On Loan to the Ashmolean Museum, Oxford.

Derbyshire baronet who lost his only child in 1791, and in memoriam composed a volume of verse dedicated to the five-year-old, titled *Sorrows: Sacred to the Memory of Penelope*. According to the story, Boothby was so consumed with grief over his loss that he neglected his estates and ended his days in poverty. Penelope had been painted at age three by Joshua Reynolds (fig. 16)—a work Dodgson knew well, for it hung in Oxford's Ashmolean Museum—and she was deified posthumously by Thomas Banks's funerary sculpture and Henry Fuseli's painting *The Apotheosis of Penelope Boothby* (1792–94).[134] The figure in Dodgson's photograph is based on the Reynolds portrait, showing Penelope in eighteenth-century costume, the very emblem of parental

devotion to childhood innocence. She represents another childhood ideal—the fated lamb of God—and is associated with the atonement of Christ through her undeserved suffering in this world.

The meaning of many of Dodgson's images can be deduced simply by identifying their subjects. His arrangement of Xie, George Herbert, Hugh, and Brook Kitchin in the tableau representing St. George and the Dragon (pl. 34) refers to the legend of the patron saint of England. George was believed to be a noble prince of Cappadocia martyred during the reign of Diocletian for defending the Christians from Roman persecution. According to the romance most frequently depicted, a pagan town in Lydda was being terrorized by a dragon, who could be placated only

by a steady diet of virgins. When George arrived in the town, he discovered that the king's daughter, Sabra, was chosen to be the next victim, so he engaged the dragon in battle. (In the Kitchin version, the body of a previous combatant lies lifeless on the ground as evidence of the danger faced.) After his victory, George married Sabra, and the town was converted to Christianity. Dodgson casts Xie as the captive princess, in the wedding gown that prefigures her destiny, and lets her take the stage alone in one of the series of separate studies he composed with the St. George actors (pl. 6).

The story had particular significance for the English, for a vision of George was said to have appeared to Richard the Lion-hearted on the eve of his defeat of the Saracens during the first Crusade. Thereafter, George was regarded as the protector of the British monarch and his army and was chosen to be the patron of the Order of the Garter. His character appears often in the nation's literature, notably Edmund Spenser's *The Faërie Queene* and John Bunyan's *Pilgrim's Progress,* as well as in William Caxton's translation of the *The Golden Legend.* Over the centuries, George became associated with the masculine ideal of discipline and self-control, the knight who represents the power of reason and overcomes the dragon, symbolizing carnality. George was also seen to embody militant Christianity, and in some ancient texts the persecutor Diocletian is referred to as the dragon, and the virtuous princess represents an oppressed but righteous church. Ruskin formed his Guild of St. George between 1869 and 1871 with this reference in mind, invoking the example

of the martyred saint in his own crusade against modern British materialism.[135] In his photograph, Dodgson follows the example of Dante Gabriel Rossetti and Edward Burne-Jones, linking the story typologically to the Annuciation, the princess a reflection of the Virgin Mary and George the stalwart Angel Gabriel.[136]

In Victorian culture, the St. George legend was directly connected to that of Andromeda and Perseus. In the classical Greek myth, Andromeda is the daughter of Ethiopia's King Cepheus and Queen Cassiopeia. When the vain queen boasts that her beauty rivals that of the sea nymphs, Poseidon sends a monster to ravage the coast. An oracle instructs Cepheus that he might appease the gods by offering his daughter Andromeda to the beast. She is chained to a rock, left naked, and is about to be devoured when Perseus, son of Zeus, materializes. He vanquishes the monster and is rewarded by being given Andromeda's hand in marriage by her grateful parents. Slaying the dragon is Perseus' final test before entering manhood; the myth ends with his coronation and the founding of the Persian (or, in some versions, Mycenaean) empire by the son they produce. Andromeda's nakedness and flowing hair are classical analogues for Sabra's wedding dress, representing her blamelessness, unself-conscious beauty, and ability to inspire heroic deeds. In Dodgson's image (pl. 36), Andromeda's bound hands readily identify her as the helpless, mythological damsel in distress.

Both Andromeda and St. George are rescue stories. Dodgson's selection of them for photographic enactment was motivated by the message each

communicates about the moral value of female innocence and virtue and man's role in protecting them. Protection was a theme he consistently returned to in his photographs, from his early study of Agnes Weld as Little Red Riding-Hood to the straitened Alice, doomed Penelope, and extricated Cinderella. *The Fair Rosamond* (pl. 33) is a legend of failed rescue. After Henry II married the French noblewoman Eleanor of Aquitaine, the king (according to tradition) took the beautiful Rosamond Clifford as his mistress. The English girl was a favorite of Henry's subjects, but the jealous Eleanor discovered the affair and had Rosamond put to death, allowing her to choose the means—by dagger or poison. In Dodgson's photograph, the vengeful queen, played by Annie Rogers, offers a sword and a cup to Rosamond, played by Mary Jackson. Rosamond, like Dodgson's other heroines, is a victim of circumstance, but in this case the king does not arrive to rescue her. Protection—and the consequences of its failure or absence—seemed to have an emotional valence for Dodgson, who identified with the knightly role both personally and artistically, devoting himself to a sanitized "Shakespeare for Girls," inserting himself into *Through the Looking-Glass* as the White Knight, even championing the rights of animals in an antivivisection campaign of the 1870s. Protection of the innocent and defenseless, of women and children, emerges as a clear subtext in his many photographic illustrations.

For the devout Dodgson, the child was a creature only recently given to the world by the Creator, the purest form of a spiritual essence hopefully retained (or reawakened) in adult life. The 1886 introduction to a reissue of *Alice* suggests childhood to be a state of mind:

> *Those for whom a child's mind is a sealed book, and who see no divinity in a child's smile, would read such words in vain: while for any one who has ever loved one true child, no words are needed. For he will have known the awe that falls on one in the presence of a spirit fresh from GOD'S hands, . . . for I think a child's first attitude to the world is a simple love for all living things.*[137]

Carroll's 1862 poem "Stolen Waters" presents the child as an icon of redemption to the soul-dead narrator, recalling him to "the joy of hearing, seeing, the simple joy of being":

> *Be as a child—*
> *So shalt thou sing for very joy of breath—*
> *So shalt thou wait thy dying,*
> *In holy transport lying—*
> *So pass rejoicing through the gate of death,*
> *In garment undefiled.*[138]

Dodgson's imagery is predicated on his belief in childish innocence as yet another alternate reality, a metaphysical state of preknowledge that grants the young in his photographic work a license to reveal to adults something of their own moral condition. This is perhaps the greatest irony in the myth of Carroll-as-pedophile; Dodgson could pose his charges in

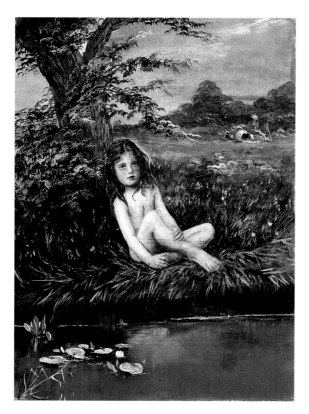

Figure 17. Lewis Carroll. *Evelyn Hatch*, 1879.
The Rosenbach Museum and Library, Philadelphia.

adult roles, give them guns, daggers, and exotic costumes, even portray them as odalisques and half-dressed waifs, because he and most of his audience believed so emphatically in their total insulation from the implications of such postures. These presentations do not so much underscore the latent sexuality of the child (as we post-Freudians would have it) as they do an obvious *lack* of it. The photographs consistently set off the otherness of the child by highlighting the relative size of things in their world. The five-year-old Xie is dwarfed by the enormity of the settee on which she reclines (pl. 3) or, later, the tea chests on which she relaxes (pls. 45 and 46); Aileen Wilson Todd is perched on a ladder (pl. 65);

and Agnes Hughes is cradled beside her father (pl. 14) to indicate the scale differential. (Size, specifically the child's awareness of its changing, is, of course, a feature of *Alice*.) Bare feet, exposed ankles, knees, and shoulders, and the immodest display of underclothes or nightdresses signify the child's defining unself-consciousness of her physical body, her special status as a pure, presexual creature. Photography gave Dodgson the ability to suspend his child subjects in a state of innocence forever, like a specimen in amber, or a butterfly preserved as if momentarily alighting.

Extraordinary as it may seem today, it was precisely this investment in the possibility of absolute innocence that sanctioned the Victorian era's sentimental love affair with children in the nude. The sexless bodies of naked tykes adorned postcards and salon paintings alike, their forms appearing not as a sexual invitation but rather an emblem of incorruptibility. Dodgson's sporadic forays into this genre (fig. 17) are wholly unexceptional. His presentation of the children of Oxford associates, "half-dressed or semi-undraped," as Nabokov put it, could hint at sensuality because they were thought free of sexuality, just as they could play at being endangered because in reality they were far from it. Our own sense of propriety, of the ambiguity of the child as a sexual entity, no longer tolerates this.

Reading Dodgson's diaries, one is struck by the regularity of parental consent to his picture-making schemes, a participation that now seems remarkable. His friends and colleagues willingly brought their children round, sometimes staying for the photographic session, sometimes leaving their offspring

in Dodgson's care, in any case learning of it subsequently and examining the photographs after they were printed. Neither the artist nor this most acute of audiences seemed troubled by the activity, any more than they would have been troubled by having Mrs. Cameron photograph their offspring. Indeed, we might well ask: if new evidence were somehow brought to light that conclusively determined that every known Dodgson photograph had actually been made by Cameron, how would it change our response to the images? What does this say about the role our expectations, our "knowledge," plays in the act of reception? Nabokov, sure in his knowledge, declared that Dodgson "got away with it" because those around him were naive and inattentive. For

him, and for many besides, the name Lewis Carroll came to signify a pathology, an unwholesome adulation of the most vulnerable segment of society, and proof of this pathology appears to those who seek it. But if Dodgson's photographs reveal such a condition, it is one that was shared by the children's parents and by the entire Victorian culture. His camera images require neither apology nor indictment, but rather our sympathetic engagement with the historical circumstances that made them possible, however remote those circumstances may have become. They are a dream, a stage, an external reflection of what we were like before we all grew older and learned how not to trust.

Notes

1. At the beginning of *Lolita*, Humbert, impotent to act upon his longing, finds writing a compensatory outlet: "I have only words to play with!" he laments (p. 32). "When I use a word," Humpty Dumpty declares in *Through the Looking-Glass*, "it means just what I choose it to mean—neither more nor less." Carroll, *Through the Looking-Glass and What Alice Found There* (1872), in *The Complete Works of Lewis Carroll* (London: Nonesuch Press, 1989), 196.

2. Vladimir Nabokov, interview by Alfred Appel, Jr., September 1966, in *Wisconsin Studies in Contemporary Literature* 8, no. 2 (Spring 1967): 143. Nabokov is evidently referring to Carroll's portrait of Alice Liddell as a beggar-maid (pl. 21).

3. The name itself is a word-game. Dodgson rendered his first and middle names, "Charles Lutwidge," in Latin to get "Carolus Ludovicus," then transposed them and translated the result back into English to get Lewis Carroll.

4. Stuart Dodgson Collingwood, *The Life and Letters of Lewis Carroll (Rev. C. L. Dodgson)* (London: T. Fisher Unwin, 1898), 272–73; Morton N. Cohen, *Lewis Carroll: A Biography* (New York: Alfred A. Knopf, 1995), 191. In 1890 Dodgson went so far as to have a circular printed, wherein he denied being connected with any book not published under his own name, and sent this in response to correspondence addressed to Lewis Carroll.

5. Diary for 1855 (the last three months of which are lost), quoted in Collingwood, *Life and Letters*, 64–65.

6. See Cohen, *Lewis Carroll*, 3–27.

7. Ibid., 38–41.

8. "Photography Extraordinary" was published in the 3 November 1855 issue of *The Comic Times*, a humor magazine that competed briefly with *Punch*.

9. The request is noted in Dodgson's diary, 22 January 1856. See Edward Wakeling, ed., *Lewis Carroll's Diaries: The Private Journals of Charles Lutwidge Dodgson*, vol. 2: January to December 1856 (Luton, England: Lewis Carroll Society, 1994), 26.

10. See Roger Taylor, " 'All in the Golden Afternoon': The Photographs of Charles Lutwidge Dodgson," in Roger Taylor and Edward Wakeling, *Lewis Carroll, Photographer: The Princeton University Library Albums* (Princeton, N.J.: Princeton University Press/Princeton University Library, 2002), 15–16.

11. Wakeling, *Diaries*, vol. 2, 25 April 1856, 65.

12. Ibid., vol. 2, 13 May 1856, 70. Before leaving for vacation, Dodgson dined with the Liddells (17 May), had Harry and Lorina—the oldest of the children—help put away library books (19 May), photographed the

children at the Deanery on his own (3 June), took Harry and Lorina on a boating expedition (5 June), and made his farewells before departing (7 June). See 70–79.

13. See Morton N. Cohen, *Reflections in a Looking-Glass: A Centennial Celebration of Lewis Carroll, Photographer* (New York: Aperture, 1998), 35 and 39.

14. The photograph, along with forty-seven others by Dodgson, was preserved in an album retained by the Liddell family and now on deposit at Christ Church. For an illustration dated 2 June 1857, see *Lewis Carroll's Alice: The Photographs, Books, Papers, and Personal Effects of Alice Liddell and Her Family* (London: Sotheby's, 2 June 2001), 71.

15. Wakeling, *Diaries*, vol. 3, 18 August 1857, 88.

16. *Photographic Society—Exhibition of Photographs and Daguerreotypes at the South Kensington Museum* (London: Taylor and Francis, 1858), 8. Under the name C. L. Dodgson, a frame with four photographs is listed: 1. Portrait, 2. Group of Children from Life, 3. Little Red Riding-Hood, 4. Portrait of a Child.

17. Taylor notes that this was a ploy Dodgson had observed Southey turn to account. The diaries indicate that Harry and Lorina were invited up to see "my book of photographs" on 22 October 1856, and that the next month the same was sent over to the mother of the Acland children, who were prospects discovered through the Liddells (vol. 2, 108, 118). February found the album with Dr. Frederick Barnes (vol. 3, 27), and in March at the Norrises (vol. 3, 39).

18. Wakeling, *Diaries*, vol. 3, 5 February 1857, 21.

19. Wakeling, *Diaries*, vol. 3, 15 June 1857, 69.

20. The printed brochure is titled "Photographs"; an example is retained in the Morris L. Parrish Collection at Princeton University Library. See Helmut Gernsheim, *Lewis Carroll: Photographer* (New York: Chanticleer Press, 1949), 46–47. My thanks to Alexander Wainwright for providing me with a copy of this document.

21. A letter from the poet Henry Taylor to Dodgson, dated 31 October 1862, suggests as much: "We are exceedingly obliged to you for all the trouble you have taken. Four of the specimens were dispatched this morning to the West Indies, viz. myself (large head), Eleanor, Harry, and Harry & Una, and we should be indebted to you if you would procure us six copies of these (Eleanor excepted) at the prices you mention. They are those I think which are the most liked. My own liking is for the Harry and the Harry & Una. Pray do as you like about distribution." Cited in Wakeling, *Diaries*, vol. 4, 140.

22. Wakeling, *Diaries*, vol. 4, 4 July 1862, 94–95.

23. See Martin Gardner, ed., *The Annotated Alice: Alice's Adventures in Wonderland and Through the Looking-Glass by Lewis Carroll* (New York: Meridian, 1960), n. 7, 44. When a facsimile edition of the original manuscript was published in 1886, Gardner notes, Dodgson forwarded a copy to Duckworth, inscribed "The Duck from the Dodo."

24. Letter from Canon Robinson Duckworth, in Stuart D. Collingwood, ed., *The Lewis Carroll Picture Book* (London: T. Fisher Unwin, 1899), 261. Dodgson did not actually begin the task of preparing the manuscript until the following November.

25. Cohen, *Lewis Carroll*, 126–33.

26. Wakeling, *Diaries*, vol. 4, 28 March 1863, 183. Dodgson owned several examples of Rejlander's work, preserved in the *Professional and Other Photographs* album at the University of Texas, Austin.

27. Ibid., vol. 4, 22 April 1863, 194.

28. Ibid., vol. 4, 25 March 1863, 177–81. Wakeling notes that by this date at least half of the subjects on the list had already been photographed.

29. On the Badcock Yard studio, see Taylor, "'All in the Golden Afternoon,'" 75–77.

30. Cohen, *Lewis Carroll*, 233–34.

31. Thirty-four photographic albums are recorded in Dodgson's estate, though some of these would have held the work of other photographers. See Edward Wakeling, "Catalogue of the Princeton University Library Albums," in Taylor and Wakeling, *Lewis Carroll, Photographer*, 123.

32. Unpublished diary entry for 7–8 August 1875, quoted by Wakeling, in "Catalogue," 126.

33. Morton N. Cohen, ed., *The Letters of Lewis Carroll* (Oxford: Oxford University Press, 1979), xvi.

34. See letter to E. Gertrude Thomson, 16 July 1885, in Cohen, *Letters*, 592, and Gernsheim, *Lewis Carroll: Photographer*, 79.

35. Wakeling, *Diaries*, vol. 4, 5 December 1863, 264.

36. Collingwood, *Life and Letters*, 355.

37. *Complete Works*, 849–52.

38. Florence Becker Lennon, *Victoria Through the Looking-Glass* (New York: Simon & Schuster, 1945), 192. For a more complete discussion, see Karoline Leach, *In the Shadow of the Dreamchild: A New Understanding of Lewis Carroll* (London: Peter Owen, 1999), 38–41.

39. Alexander L. Taylor, *The White Knight* (Edinburgh: Oliver and Boyd, 1952), v, as cited by Leach, *In the Shadow*, 42.

40. Cohen, *Lewis Carroll*, 100–104. "Add to the cloud that settled on Charles at his father's death Alice's rejection of him and her marriage to [Reginald] Hargreaves, and we see ample reasons for the guilt and disappointment that belie the happy man he sometimes claimed to be" (342). Addressing the excised pages from 1863, Wakeling reports that in 1996 a paper was uncovered in the Dodgson Family Archive, written by one of the nieces, that gives a brief extract of the contents of the missing sections of the diary. It suggests an entirely different reason for the break: "L. C. learns from Mrs. Liddell that he is supposed to be using the children as a means of paying court to the governess. He is also supposed by some to be courting Ina." Rumors of Dodgson's

interest in the Liddells' governess, Miss Prickett, had been circulating around Oxford since 1857. Ina (Lorina) Liddell was thirteen at the time. Though neither suggestion was likely true, the sensitive Dodgson and the socially conscious Liddells would probably have agreed that a period of separation would be the best remedy for the gossip. See Wakeling, *Diaries*, vol. 4, 214–15. As Leach, the discoverer of the document, points out, the missing passage had nothing to do with Alice, let alone a marriage proposal, and once the rumors blew over, Dodgson resumed his normal relations with the family (170–72).

41. For example, when Dodgson visited the Deanery on 21 April 1863 to check on Alice, who was grounded with a sprained leg, he found her "in an unusually imperious and ungentle mood by no means improved by being an invalid" (Wakeling, *Diaries*, vol. 4, 193). This was one of the lines Dodgson's nieces tried to obliterate, suggesting just how sensitive they were to preserving a wholesome and uncomplicated Carroll legend. On 11 May 1865, Dodgson writes (rather dispassionately): "Met Alice and Miss Prickett in the quadrangle. Alice seems changed a good deal, and hardly for the better, probably going through the usual awkward stage of transition." At the time, she had just turned twelve. (Wakeling, *Diaries*, vol. 5, 11 May 1865, 74.) Most of the other mentions of Alice are in the context of a family group.

42. Like every holder of his position, Dodgson was expected by university bylaws to take holy orders within four years of receiving his M.A. or renounce his studentship and income. In his case, this should have transpired no later than 1861. Why he remained in his position despite never proceeding to full orders has remained a mystery, as the circumstances leading up to this non-event fall precisely in the blackout years of the missing diaries. That taking orders was Dodgson's intention (and his father's ambition for him) seems probable, but whether it was his love of the theater, his acute sense of the absolute faith required to take final vows in good conscience, a more general question about the clergy as a calling, or some crisis in his personal life that interfered, at the last moment he took deacon's vows and did not advance further. For reasons that are undocumented, Dean Liddell waived the requirement of Dodgson's ordination and allowed him to remain at Christ Church as a "lay" student. The mystery is compounded by a change in self-regard Dodgson evidently underwent around the time. From 1862 to 1866, the extant diaries become filled with frequent supplications for divine forgiveness and a profound sense of sinfulness, of a character unlike that of the earlier volumes. Lack of substantive evidence indicating what would have induced this intensified sense of unworthiness continues to license speculation about the exact events in Dodgson's life that would have prevented ordination (if that was his plan) and left him feeling spiritually threatened.

43. See entry for 31 July 1857, in Wakeling, *Diaries*, vol. 3, 85–86.

44. Leach, *In the Shadow*, 19–24.

45. Ibid., 23.

46. Collingwood, *Life and Letters*, 360.

47. Ibid., 367. Dodgson's own view of what constituted a "child-friend" became more elastic with the years. "My views about children

are changing," he writes to his publisher, Macmillan, in 1877, "and I *now* put the nicest age at about 17!" To the mother of some new acquaintances, he writes, "Twenty and thirty years ago, 'ten' was about my ideal age for such friends; now 'twenty' or 'twenty-five' is nearer the mark. Some of my dearest child-friends are 30 or more; and I think an old man of 62 has the right to regard them as being 'child-friends' still." Quoted in Cohen, *Lewis Carroll*, 462.

48. A. M. E. Goldschmidt, "'Alice in Wonderland' Psycho-Analysed," *New Oxford Outlook* 1, no. 1 (May 1933): 70. It has since been suggested that Goldschmidt's article was published to spoof Freudian concepts—an undergraduate hoax—but even if that were the case, its premise was apparently taken seriously enough to encourage further, serious elaborations.

49. Ibid.

50. Ibid.

51. William Empson, *Some Versions of Pastoral* (London: Chatto and Windus, 1935), 273.

52. Langford Reed, *The Life of Lewis Carroll* (London: W. and G. Foyle, 1932).

53. Phyllis Greenacre, M.D., *Swift and Carroll: A Psychoanalytic Study of Two Lives* (New York: International Universities Press, 1955), 138, 141, 154, 179.

54. Ibid., 134.

55. Leach, *In the Shadow*, 37.

56 . Clarence H. White, "Old Masters in Photography," *Platinum Print* 1, no. 7 (February 1915): 4. White reproduces Coburn's essay on the subject from *Century Magazine* 90 (1915). The exhibition was also seen at the Ehrich Galleries in New York.

57. Helmut Gernsheim, preface to *Lewis Carroll*, v.

58. Helmut Gernsheim, *Julia Margaret Cameron: Her Life and Photographic Work* (London: Fountain Press, 1948).

59. Gernsheim, *Lewis Carroll: Photographer*, 29.

60. Ibid., 29–30. Lindsay Smith's reading of Gernsheim's texts concludes that they mean the opposite of what they say: that he prefers Carroll's feminine "no-ambition" to the threat of Cameron's masculine "great ambition" in photography. See Lindsay Smith, *The Politics of Focus: Women, Children and Nineteenth-Century Photography* (Manchester: Manchester University Press, 1998), 24–27.

61. Gernsheim, *Lewis Carroll: Photographer*, 16.

62. Ibid., 18.

63. This extended to their craft as well: "The same inherent contrast in their personalities is evident in their technique: Mrs. Cameron was slapdash, Lewis Carroll neat." Ibid., 30.

64. Ibid., vi.

65. Gernsheim details his circuitous research in his introduction to *Lewis Carroll, Victorian Photographer* (London: Thames and Hudson, 1980), 7–11.

66. Gernsheim later wrote: "The publication of my book Lewis Carroll Photographer in 1949 caused quite a sensation in literary and artistic circles. I had succeeded in uncovering new aspects of Lewis Carroll's life and character which had not been suspected. I had been able to prove that photography had been Lewis Carroll's main interest in life, but it was obvious to many critics that some of the photographs of pretty little girls could only be interpreted as expressions of repressed desire. The eccentricities of the dry Oxford don of mathematics who preferred the company of little girls to any high-brow conversation were now seen in a new light." Gernsheim, introduction to *Victorian Photographer*.

67. Greenacre, *Swift and Carroll*, 144–46.

68. "Photographs by Lewis Carroll, Author of 'Alice,' to go on view," The Museum of Modern Art, September 1950. The exhibition was on view from 27 September to 19 November 1950.

69. Edward Steichen, wall text for the exhibition "Photographs by Lewis Carroll (Rev. Charles L. Dodgson, 1832–1898) Author of 'Alice.'" Courtesy Photography Department, The Museum of Modern Art, New York.

70. Gernsheim, *Lewis Carroll: Photographer*, 31–32, 51.

71. Ibid., 22.

72. Ibid., 20–21.

73. Gernsheim, *Cameron*, 81.

74. "Mesmeric rapport" refers to the Victorian belief in mesmerism, a healing technique developed in the late eighteenth century by the physician Franz Anton Mesmer. Mesmer proposed that the body is filled with an energetic fluid, capable of communion with other charged objects in the universe through what he called "animal magnet-ism." During the healing procedure, the mesmerist established a con-nection with the patient by staring deeply into (usually) her eyes, inducing a hypnotic trance, and then restoring internal harmony by passing his hands lightly over her body. On the subject, see Alison Winter, *Mesmerized: Powers of Mind in Victorian Britain* (Chicago and London: University of Chicago Press, 1998).

75. "Milk-and-Water": feeble or insipid discourse, mawkish sentiment. The expression was used at the time in connection with the novels of William Makepeace Thackeray and Charles Dickens.

76. "Photography Extraordinary," reprinted in Gernsheim, *Lewis Carroll: Photographer*, 106–9.

77. "Scotland" was the nickname of the dungeon in Auckland Castle, the twelfth-century seat of the bishop of Durham in Yorkshire. When Longley served this bishopric, from 1856 to 1860, he and his family resided there. See "The Legend of 'Scotland,'" in Collingwood, ed., *Lewis Carroll Picture Book*, 241–46.

78. "A Photographer's Day Out" was originally published in the *South Shields Amateur Magazine* in 1860. It is reprinted in Gernsheim, *Lewis Carroll: Photographer*, 116–20.

79. Francis Frith, "Mount Horeb," *Egypt and Palestine Photographed and Described* (London: James Virtue, 1858–60), n. p.

80. The best discussion of typology in the photographic art is in Mike Weaver, *Whisper of the Muse: The Overstone Album & Other Photographs by Julia Margaret Cameron* (Malibu, Calif.: J. Paul Getty Museum, 1986). See also Mike Weaver, *Julia Margaret Cameron, 1815–1879* (Southampton, England: John Hansard Gallery, 1984).

81. Adrian Desmond. *Archetypes and Ancestors: Palaeontology in Victorian London, 1850–1875* (Chicago: University of Chicago Press, 1982), esp. 42–48.

82. O. G. Rejlander, "What Photography Can Do in Art," *Yearbook of Photography and Photographic News Almanac* (1867), 50, cited by Stephanie Spencer, "O. G. Rejlander Art Studies," in Mike Weaver, ed., *British Photography in the Nineteenth Century: The Fine Art Tradition* (Cambridge and New York: Cambridge University Press, 1989), 121.

83. Dodgson evidently considered the composition sufficiently realized in this instance to present the print as it was and append a couplet from Scott's poem to the mount. See Cohen, *Reflections in a Looking-Glass*, 114.

84. See Quentin Bajac, *Tableaux Vivants: Fantaisies photographiques victoriennes (1840–1880)* (Paris: Réunion des Musées Nationaux, 1999), 5.

85. Quoted in Michael Cohen, *Engaging English Art: Entering the Work in Two Centuries of English Painting and Poetry* (Tuscaloosa and London: University of Alabama Press, 1987), 3.

86. Joshua Reynolds, *Discourses*, edited by Robert Wark (New Haven: Yale University Press, 1981), 259.

87. John Ruskin, quoted in Elizabeth K. Helsinger, *Ruskin and the Art of the Beholder* (Cambridge, Mass.: Harvard University Press, 1982), 55.

88. Cohen, *Lewis Carroll*, 158.

89. Charles Dodgson, letter to William Wilcox, 11 May 1859, cited in Wakeling, *Diaries*, vol. 4, 17.

90. That contemporaries understood the challenge of this problem is indicated in the *Athenaeum*'s review of *Alice*, 16 December 1865: "This is a dream story—but who can, in cold blood manufacture a dream, with all its loops and ties, and loose threads and entanglements, and inconsistencies and passages which lead to nothing, at the end of which sleep's most diligent pilgrim never arrives?" Quoted in Greenacre, *Swift and Carroll*, 153. Consciousness is also a theme in the later *Sylvie and Bruno* story, which moves between "waking" and "eerie" states: "Either I've dreamed about Sylvie," the narrator says to himself, "and this is the reality. Or else I've been with Sylvie, and this is the dream! Is Life itself a dream, I wonder?" *Sylvie and Bruno*, chap. 2, in Carroll, *Complete Works*, 272. See also R. B. Shaberman, "Which Dreamed It?," in *Under the Quizzing Glass: A Lewis Carroll Miscellany* (London, Magpie Press, 1972), 15–29.

91. Martin Gardner notices the prevalence of invisibility and nonexistence in the stories: "The March Hare offers Alice some nonexistent wine; Alice wonders where the flame of the candle is when the candle is not burning; the map in *The Hunting of the Snark* is 'a perfect and absolute blank'; the King of Hearts thinks it unusual to write letters to nobody, and the White King compliments Alice on having keen enough eyesight to see nobody at a great distance down the road." Gardner, *The Annotated Alice*, 182.

92. In his diary Dodgson writes: "The case was a man with an abscess below the knee-joint, which had to be cut into and examined. This was done under the influence of chloroform, Lawrence being the operating surgeon. The chloroform took several minutes to act fully, producing first convulsions, and then stupor like that of a man dead drunk." Entry for 19 December 1857, in Wakeling, *Diaries*, vol. 3, 138.

93. Quoted in Collingwood, *Life and Letters*, 321.

94. Beaumont Newhall, *The History of Photography from 1839 to the Present* (New York: The Museum of Modern Art, 1982), 75. According to Dodgson's diary for 13 July 1863, he attempted to make "ghost" photographs, two each of the Brodies and the Donkinses, but these have apparently not survived. Wakeling, *Diaries*, vol. 4, 219.

95. See Cohen, *Lewis Carroll*, 368, and Alan Gauld, *The Founders of Psychical Research* (London: Routledge & Kegan Paul, 1968), 140.

96. Letter to James Langton Clarke, 4 December 1882, in Cohen, *Letters*, vol. 1, 427.

97. Wakeling *Diaries*, vol. 3, 12 September 1857, 103. Dodgson later approached Paton to illustrate the sequel to *Alice*, but was not accommodated; Paton recommended Tenniel again as best fit for the task.

98. Jeremy Maas et al., *Victorian Fairy Painting* (London: Merell Holberton, 1997), 66, 108–12, 114–17.

99. Cohen, *Letters*, 463.

100. Lewis Carroll, *Symbolic Logic and The Game of Logic* (New York and Berkeley: Dover, 1958), 1–2. Dodgson managed to publish only the first part of *Symbolic Logic*, which was titled "Elementary." The manuscripts for Part II, "Advanced," and Part III, "Transcendental," were unfinished when he died.

101. Gardner, *The Annotated Alice*, 172. Gardner points out that the White Knight develops a hierarchical brand of nominalist logic in his song (" 'A-Sitting on a Gate,' *called* 'Ways and Means'; the *name* of which is 'The Aged Aged Man,' which name is called 'Haddock's Eyes' "), befitting the infinite regress of the mirror world and the hierarchical structure of the chessboard (306–7).

102. Hugues Lebailly has determined that Dodgson's devoted theater-going was not as chaste, nor as child-oriented, as his reputation would have it. He attended performances (at least 489 as an adult) at the best theaters, but he also notes his enjoyment of those mature female actresses typically inserted into stage productions for the sake of their "physical attractions" and skimpy, tight costumes. Late in life he records visits to decidedly dubious recreations, such as Miss Saigeman's swimming entertainment. Such activities were the kinds of behavior that embarrassed his family, and his nieces made every effort to bowdlerize all mention of them from the diaries. What remained was a preponderance of entries about child-actors. See Hugues Lebailly, "C. L. Dodgson and the Victorian Cult of the Child: A Reassessment in the Centenary Year of Lewis Carroll's Birth," *The Carrollian*, no. 4 (Autumn 1999): 3–31.

103. One of the friends Dodgson made through the theater, A. W. Dubourg, wrote of him: "I gathered from my intercourse with Lewis Carroll that, subject to rigid limits as to the moral character of the play, he had considerable sympathy with the drama, believing that within those limits the stage might have a valuable and elevating influence upon all classes of playgoers and upon the public generally; but with regard to the slightest transgression of those limits he was greatly sensitive, perhaps super-sensitive to the mind of the layman, and I have known him leave a theatre in the midst of a performance for a very small deviation from the line he had marked out." Collingwood, ed., *Lewis Carroll Picture Book*, 124.

104. Lewis Carroll, "The Stage and the Spirit of Reverence," *The Theatre* (June 1888), in Collingwood, ed., *Lewis Carroll Picture Book*, 135.

105. Wakeling, *Diaries*, vol.1, 22 June 1855, 105–6.

106. Diane Waggoner devotes a chapter of her dissertation, "In Pursuit of Childhood: Lewis Carroll's Photography and the Victorian Visual Imagination" (Yale University, 2000), to the topic of the theater. Waggoner is currently preparing a book-length study of Dodgson's photography.

107. Wakeling, *Diaries*, vol. 3, 3 July 1857, 81.

108. Dodgson notes that Henry Le Jeune's *Queen Katherine's Dream* in the Royal Academy show of 1857 was based on the Kean performance he had witnessed. See Taylor, "'All in the Golden Afternoon,'" 29.

109. In a letter to his family, dated 18 December 1860, Dodgson writes: "The *tableaux vivants* were *very* successful. . . . One of the prettiest was Tennyson's The Sleeping Princess, acted entirely by the children. The grouping was capital, I believe by Lady W[illiamson]. I was sure it could not be by Mrs. Liddell, of whose taste in that line I have already had melancholy experience in my photographs. I shall try and get them to go through it by daylight in the summer. It would make a beautiful photograph." Cohen, *Letters*, 45.

110. See Sara Stevenson and Helen Bennett, *Van Dyck in Check Trousers: Fancy Dress in Art and Life, 1700–1900* (Edinburgh: Scottish National Portrait Gallery, 1978), and Juliet Hacking, *Princes of Victorian Bohemia: Photographs by David Wilkie Wynfield* (London: National Portrait Gallery, 2000).

111. "Prologue," in *Complete Works*, 738–39.

112. Gardner, *The Annotated Alice*, 103.

113. The history of childhood's social construction presented here is essentially that narrated by Neil Postman, *The Disappearance of Childhood* (New York: Vintage Books, 1994).

114. Philippe Ariès, *Centuries of Childhood*, trans. by Robert Baldrick (New York: Random House, 1962), 128; Anne Higonnet, *Pictures of Innocence: The History and Crisis of Ideal Childhood* (London: Thames and Hudson, 1998), 17.

115. "The Cult of the Child" was the title of Ernest Dowson's article on the subject, in *The Critic*, 17 August 1889, and he was evidently an active participant in the worship. See Lebailly, "Victorian Cult of the Child," 13–15.

116. Postman, *Disappearance of Childhood*, 57–60.

117. In *Hyperion*, Friedrich Hölderlin has the novelist's hero espouse the Romantic view when he calls the child "a divine being as long as it has not been dipped in the chamaeleon dye of men," and wishes that "one might become like children, so that the golden time of innocence might return." Cited in Peter Gay, *The Naked Heart: The Bourgeois Experience from Victoria to Freud* (New York: W. W. Norton, 1995), 47.

118. Coventry Patmore, *The Angel in the House* (London: John W. Parker, 1854).

119. See Bram Dijkstra, *Idols of Perversity: Fantasies of Feminine Evil in Fin-de-Siècle Culture* (New York and Oxford: Oxford University Press, 1986), esp. 3–24.

120. John Ruskin, "Of Queen's Gardens," *Sesame and Lilies* (1865), in *Ruskin's Works* (New York: American Publishers Corporation, n. d.), 82–84.

121. On Dodgson's regard for Patmore, see Wakeling, *Diaries*, vol. 1, 1 August 1855, 114–15; for an example of his views on marriage, see letter to Edith Lucy, in Cohen, *Letters*, 1040.

122. Thomas Hughes, *Tom Brown's School Days* (Cambridge, England: Macmillan, 1857).

123. The entry for 14 January 1858 notes, for instance: "Walked with my Father to call at Skelton. . . . Dined at the Palace, with a party from the Residence, the children all appeared in the course of the evening. I especially admire the eldest boy, Robin. His thoughtful and intellectual face make him look some years older than he is. The youngest boy is also a beauty, the others are not so remarkable." Wakeling, *Diaries*, vol. 3, 150. Among the handful of surviving nude studies of children by Dodgson is one of Bertram Rogers, brother of his godson Clement, at age one, which is illustrated in Cohen, *Lewis Carroll*, 315.

124. Dodgson, probably in the company of Southey, made a suite of photographs at the Twyford School around 1858, several of which were offered for sale on his 1860 price list. Diane Waggoner devotes the third chapter of her dissertation to examining the implications of these works for the author, noting that Twyford was attended by not only his former student Harry Liddell, but also Dodgson's three younger brothers and his nephew James.

125. *Bringing Home the May* was the title of a large 1862 composite photograph, made from nine negatives, that Henry Peach Robinson displayed at the annual exhibition of the Photographic Society in February 1863. Its theme very likely inspired Dodgson, whose reinterpretation was made in July of the same year. See Margaret F. Harker, *Henry Peach Robinson: Master of Photographic Art, 1830–1901* (Oxford: Basil Blackwell, 1988), 34–38.

126. Alfred Tennyson, "The May Queen," in *Poems* (London: Edward Moxon, 1857), 132.

127. See Virginia Dodier, *Lady Hawarden: Studies from Life, 1857–1864* (New York: Aperture, 1999), 90–92.

128. Sir Walter Scott, *The Lady of the Lake* (Edinburgh: J. Ballantyne, 1810).

129. The poem begins, interestingly, with a dedication to a child, Gertrude Chataway, whom he met at the beach on the Isle of Wight ("Girt with a boyish garb for boyish task, Eager she wields her spade").

130. "Poor Little Joe," a popular song of the day by the composer G. A. St. Albens, begins:

> Cold, cold was the night, the snow had been falling
> The wind it was whistling so shrill though the street
> When on a doorstep a poor lad was lying
> No cap on his head, no shoes on his feet.

The same summer that he posed Alice, Dodgson posed Quintin Twiss as "the Artful Dodger" from Dickens's *Oliver Twist*, and as the lowly rat catcher from Harold Priestly's *The Rat Catcher's Daughter*.

131. Jennifer Green-Lewis discusses how Hugh Welch-Diamond, chief superintendent of the female wing of the Surrey Lunatic Asylum near London, staged "before and after" photographs of the insane. Diamond was editor of the Journal of the Photographic Society of London, and an acquaintance of Dodgson's uncle Skeffington Lutwidge, himself Commissioner of Lunacy in London, as well as a barrister. See Jennifer Green-Lewis, *Framing the Victorians: Photography and the Culture of Realism* (New York: Cornell University Press, 1996), 171.

132. Collingwood, *Life and Letters*, 79.

133. Wakeling, *Diaries*, vol. 4, 4 July 1864, 324.

134. The story of Penelope Boothby remained current in Dodgson's time through her father's elegies. See, for example, the discussion in *Notes and Queries* 5, no. 133 (15 May 1852): 476.

135. Adreinne Auslander Munich, *Andromeda's Chains: Gender and Interpretation in Victorian Literature and Art* (New York: Columbia University Press, 1989), 181. Ruskin became Slade Professor at Oxford, and thus formally Dodgson's colleague, in the years just prior to the photograph.

136. Ibid., 118–23.

137. Quoted by Waggoner, "In Pursuit of Childhood," 29.

138. *Complete Works*, 866–67.

PLATES

As Dodgson did not give proper titles to the majority of his photographs,
most of the following titles are derived from his informal descriptions of his pictures.
In the few cases where he did actually title a work, that title is given in quotation marks.

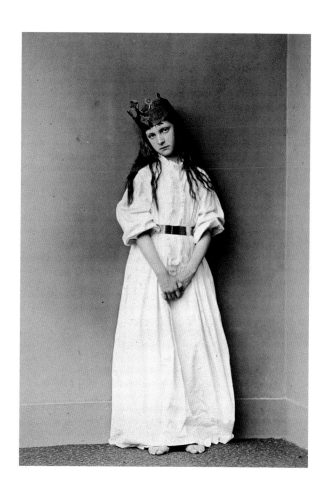

PLATE 6. *"Captive Princess" (Xie Kitchin Wearing a Crown)*, 1875

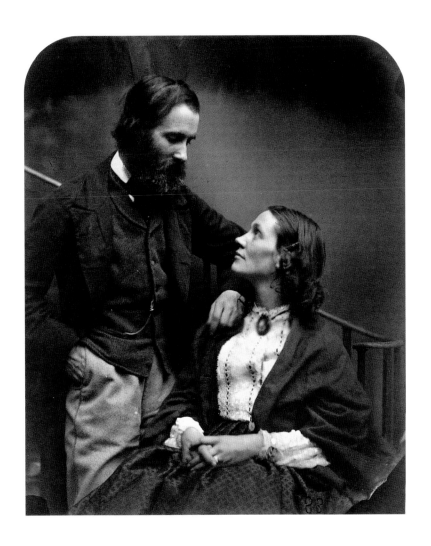

PLATE 7. *Alexander Munro, the Sculptor, with His Wife, Mary,* 1863

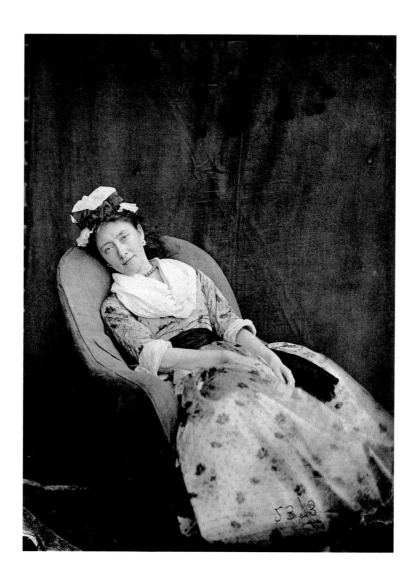

PLATE 8. *Florence Terry*, 1875

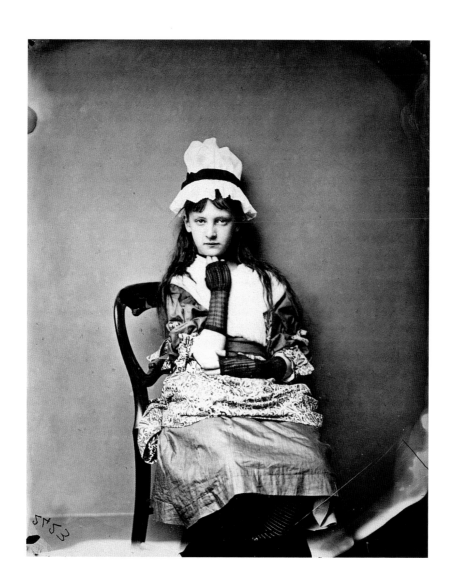

PLATE 9. *Xie Kitchin as Penelope Boothby*, 1876

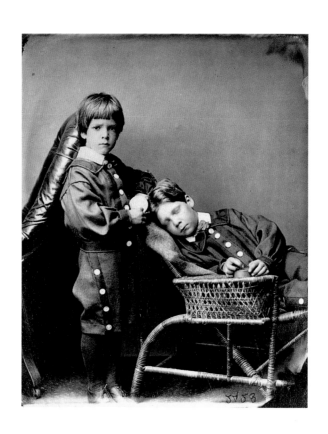

PLATE 10. *Brook and Hugh Kitchin*, 1876

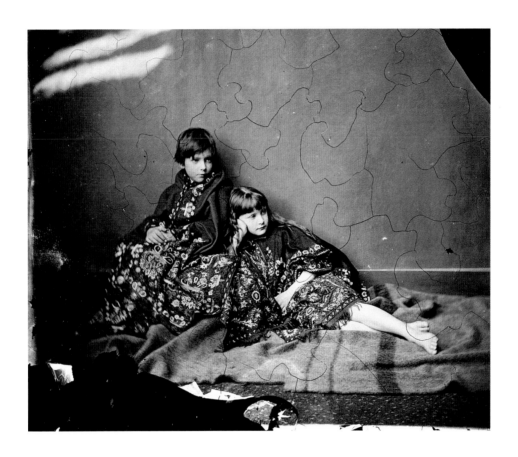

PLATE 11. *Xie Kitchin and Her Brother George Herbert*, 1873

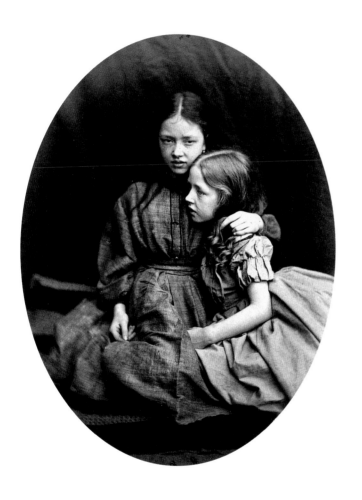

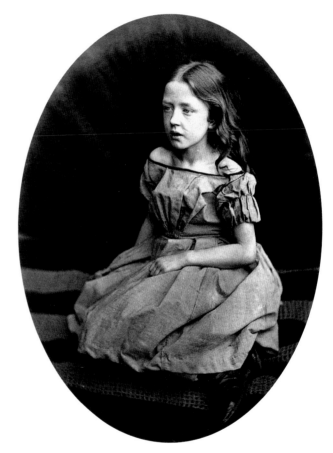

PLATE 12. *Marion "Polly" Terry and Her Sister Florence "Flo,"* 1865

PLATE 13. *Florence Maude Terry,* 1865

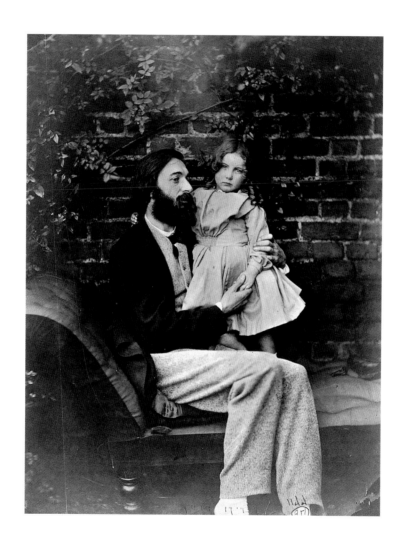

PLATE 14. *Arthur Hughes, the Artist, and His Daughter Agnes*, 1863

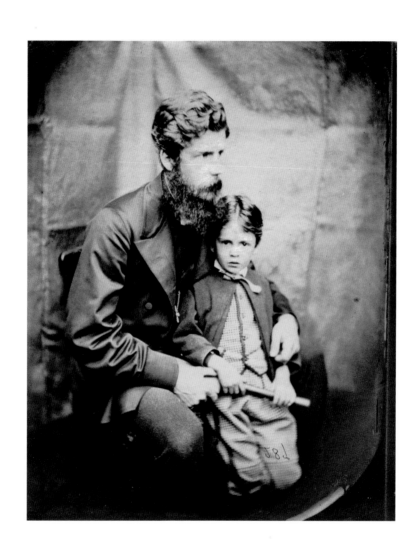

PLATE 15. *Rev. James Langton Clarke with His Son, Charles Langton*, 1864

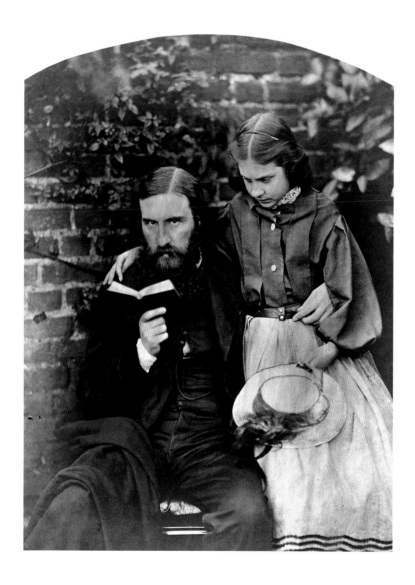

PLATE 16. *George MacDonald and His Daughter Lily "Lilia" Scott MacDonald,* 1863

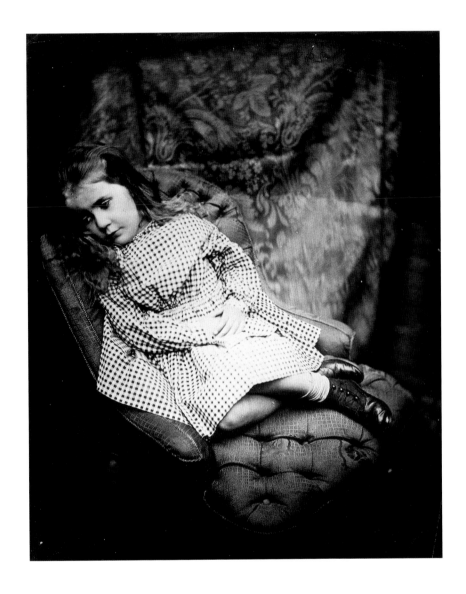

PLATE 17. *Margaret Frances Langton Clarke*, 1864

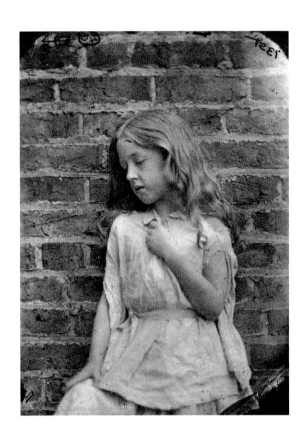

PLATE 18. *Florence Maude Terry as Cinderella*, 1865

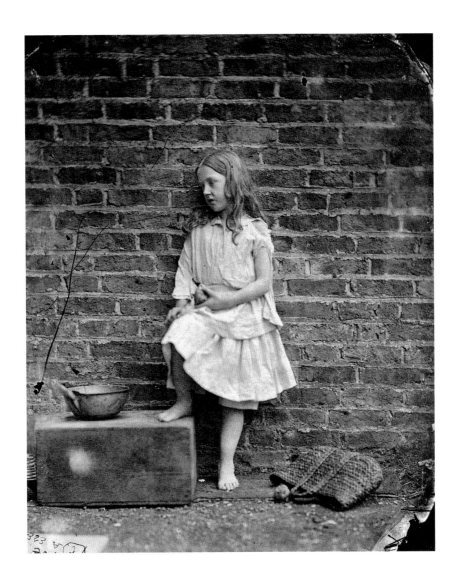

PLATE 19. *Florence Maude Terry*, 1865

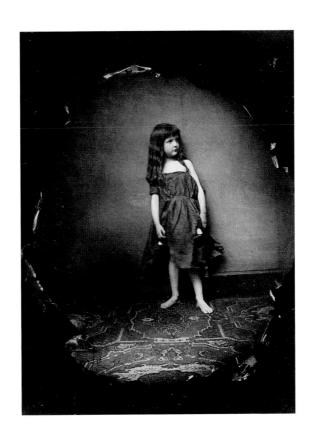

PLATE 20. *"The Prettiest Doll in the World,"* 1870

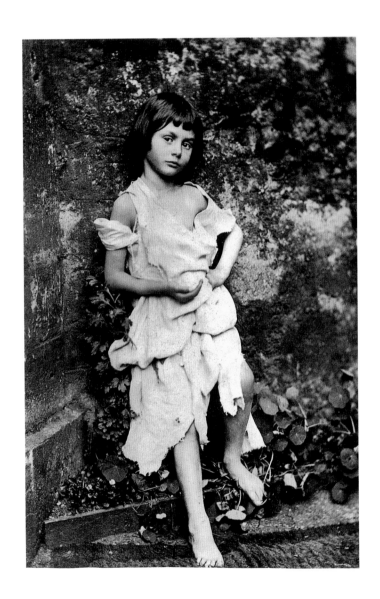

PLATE 21. *Alice Liddell as "The Beggar-Maid,"* 1858

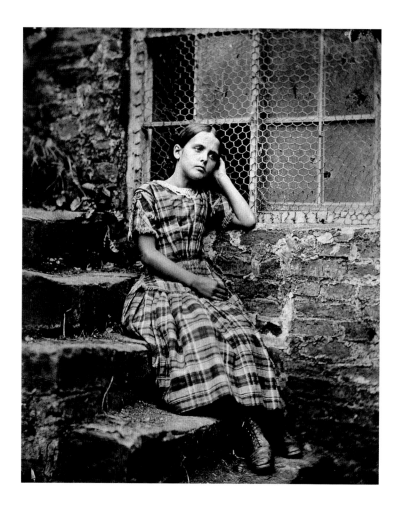

PLATE 22. *Annie Coates, Daughter of William and Isabella Coates, Croft,* 1857

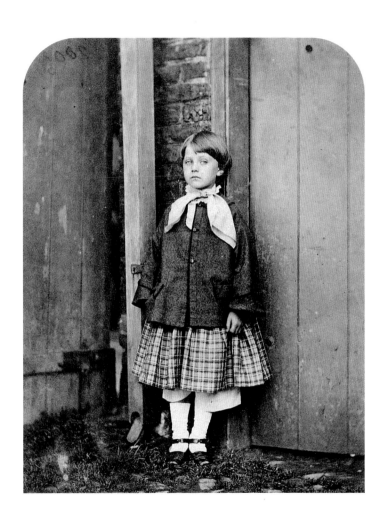

PLATE 23. *Sarah Hobson*, 1857

PLATE 24. *Alice Liddell Feigning Sleep, a Hat by Her Side*, 1860

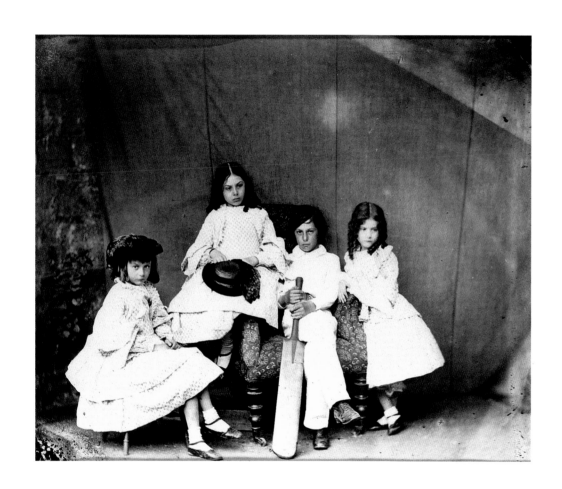

PLATE 25. *Alice, Lorina, Harry, and Edith Liddell*, 1860

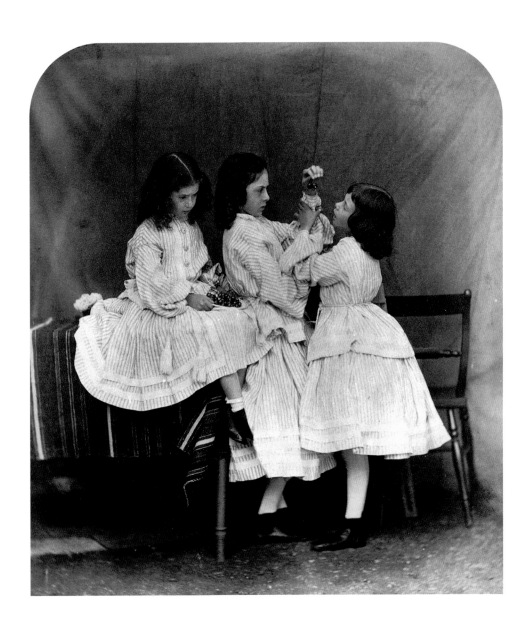

PLATE 26. *"Open Your Mouth and Shut Your Eyes,"* 1860

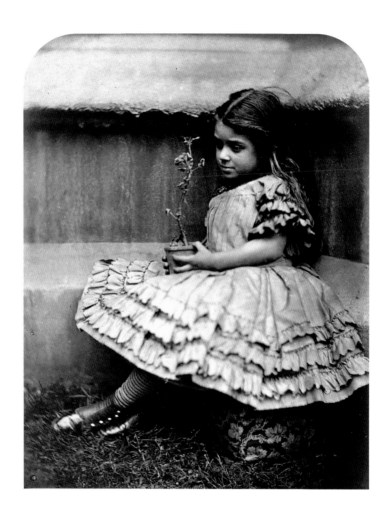

PLATE 27. *Maria White, Niece of the Porter at Lambeth Palace,* 1864

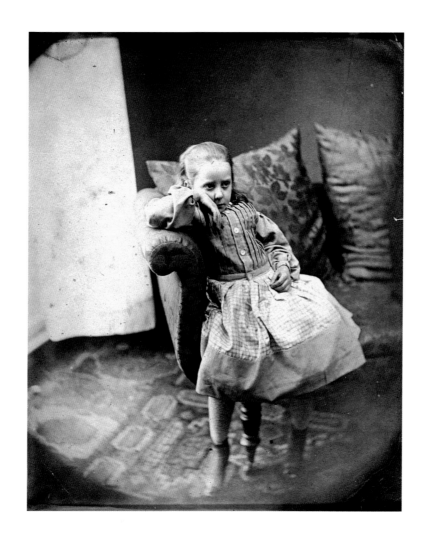

PLATE 28. *Ella Chlora Monier-Williams*, 1866

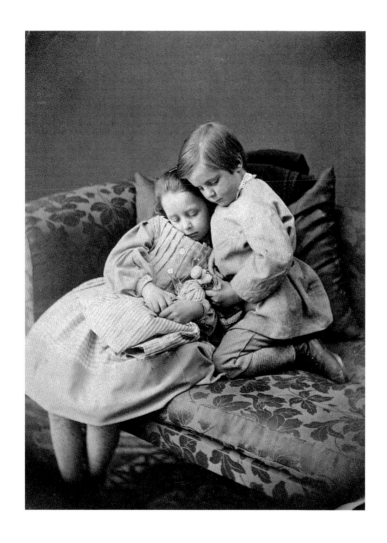

PLATE 29. *Ella Chlora Monier-Williams and a Younger Brother*, 1866

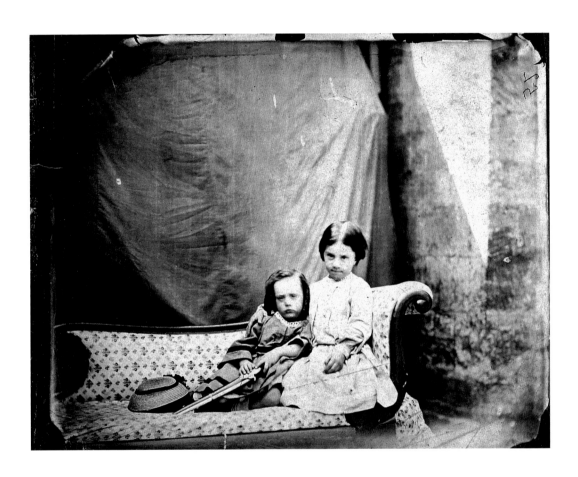

PLATE 30. *Annie and Henry Rogers,* 1861

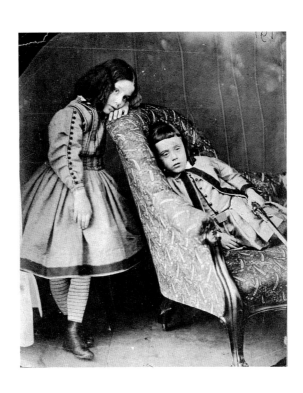

PLATE 31. *Annie and Henry Rogers,* 1863

PLATE 32. *Annie Rogers*, 1863

PLATE 33. *The Fair Rosamond*, 1863

PLATE 34. *"St. George and the Dragon,"* 1875

PLATE 35. *Marion "Polly" Terry*, 1875

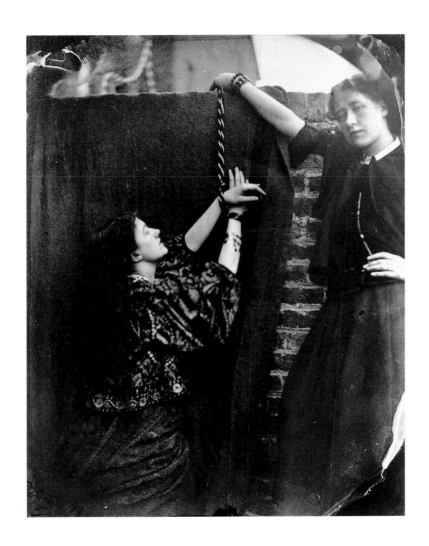

PLATE 36. *"Andromeda,"* 1865

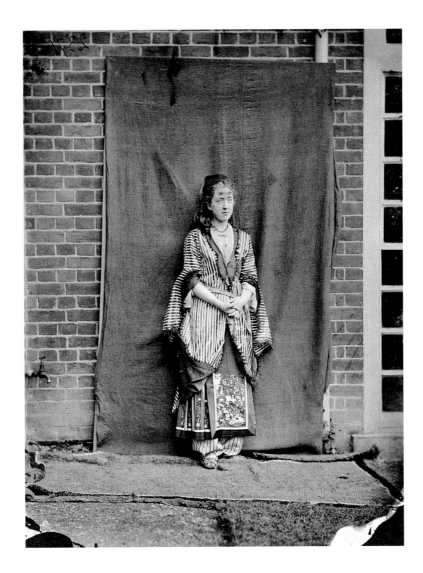

PLATE 37. *Florence Terry Dressed as a Turk*, 1875

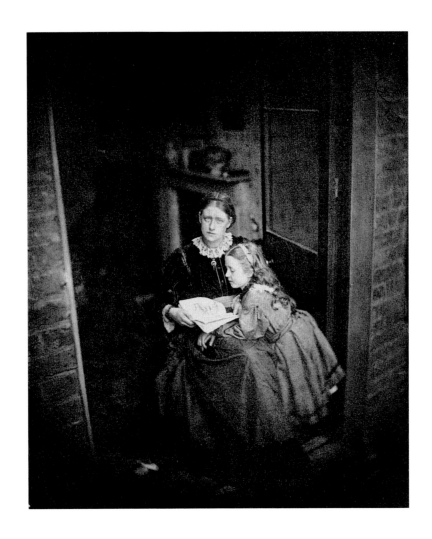

PLATE 38. *Ellen Terry and Her Sister Florence, 1865*

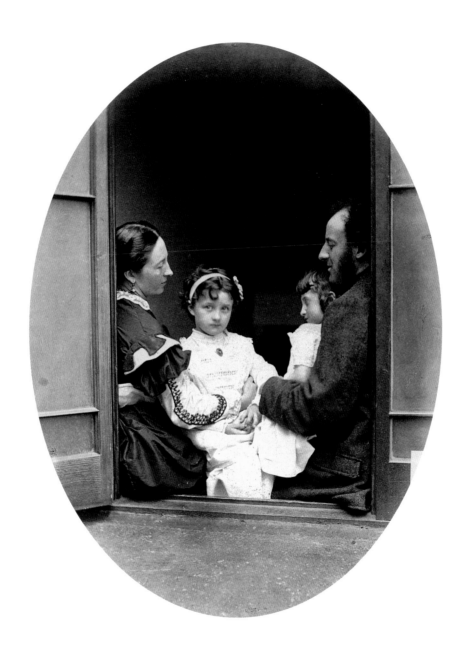

PLATE 39. *John Everett Millais, His Wife, and Two of Their Daughters,* 1865

PLATE 40. *Reginald Southey and Skeletons*, 1857

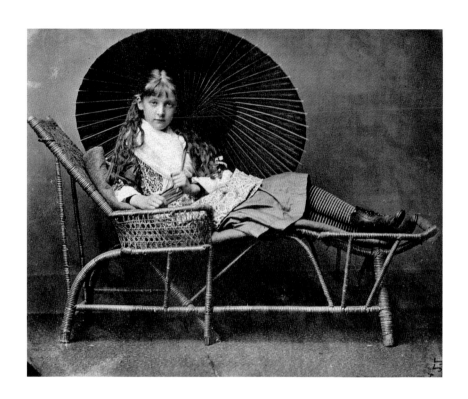

PLATE 41. *Xie Kitchin Reclining in a Cane Chair*, 1876

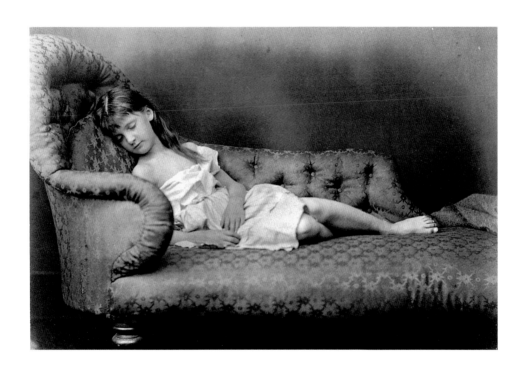

PLATE 42. *Xie Kitchin*, 1872

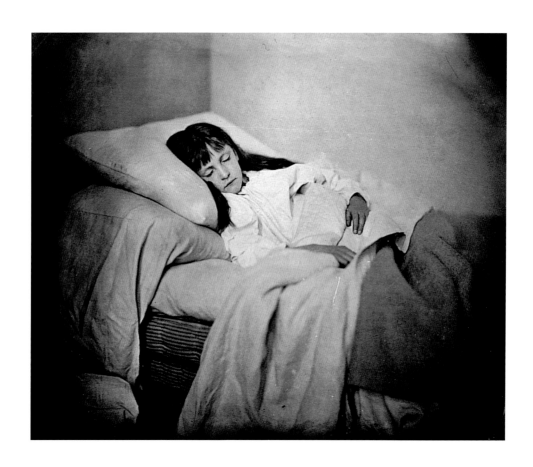

PLATE 43. *"Rosy Dreams and Slumbers Light,"* 1873

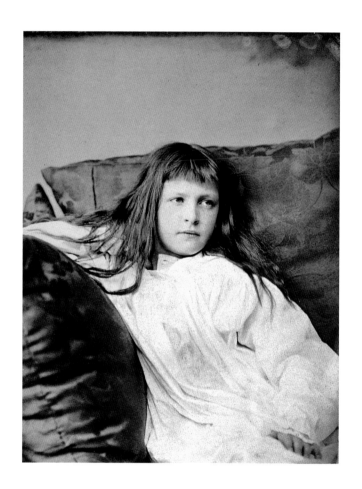

PLATE 44. *"Sleepless,"* 1874

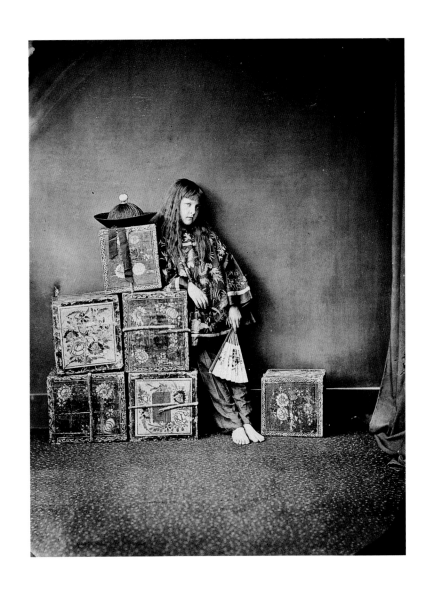

PLATE 45. *"Off Duty,"* 1873

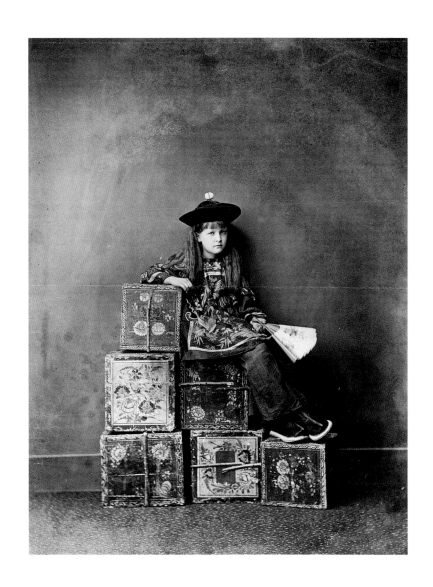

PLATE 46. *"On Duty,"* 1873

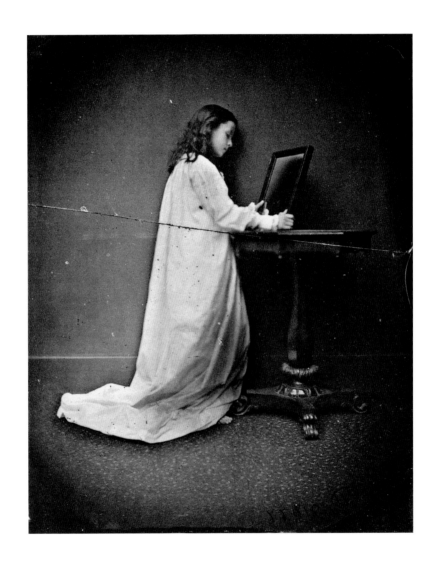

PLATE 47. *"Little Vanity,"* 1874

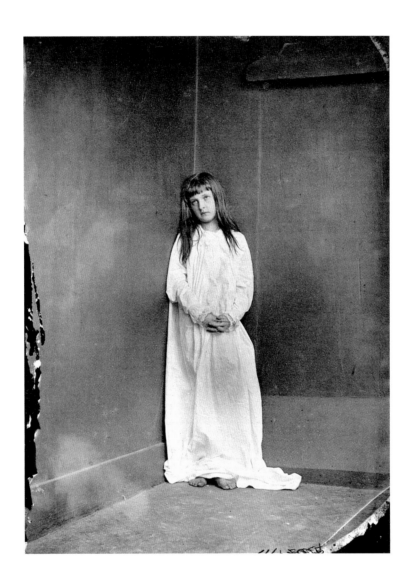

PLATE 48. *"Penitence,"* 1874

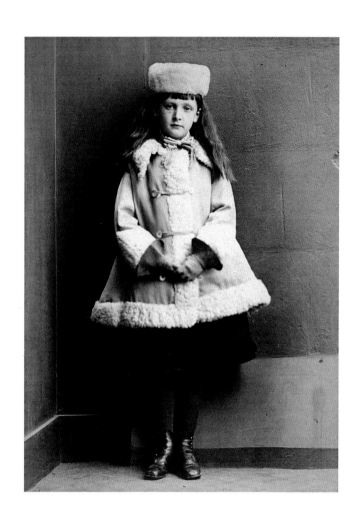

PLATE 49. *"Xie Kitchin as Dane,"* 1873

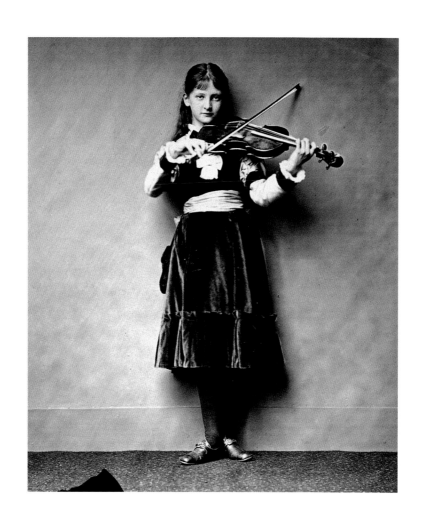

PLATE 50. *"Tuning,"* 1876

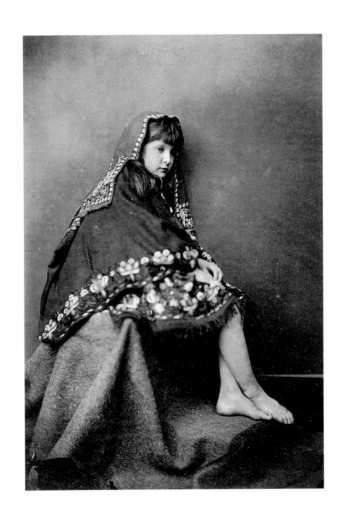

PLATE 51. *"High Caste,"* 1873

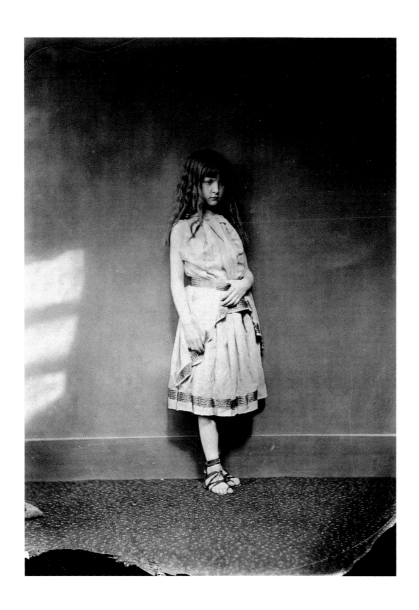

PLATE 52. *Xie Kitchin (in Greek Dress)*, 1873

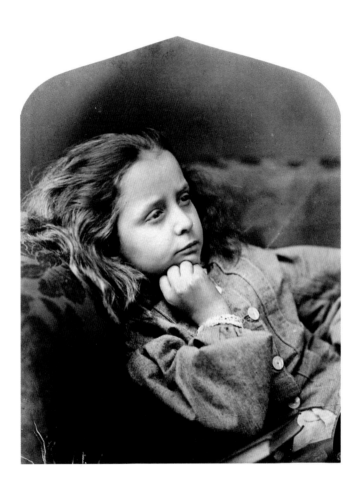

PLATE 53. *Ella Chlora Monier-Williams*, 1866

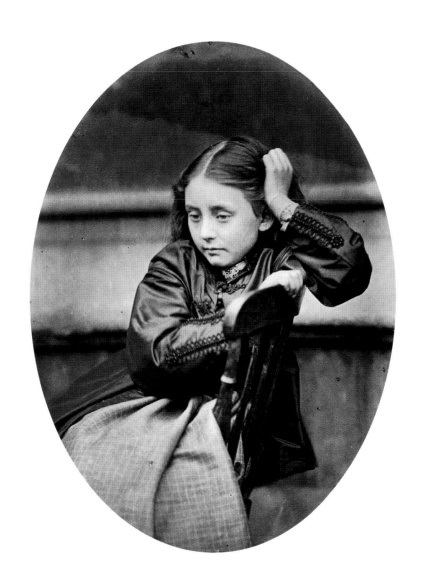

PLATE 54. *Ella Sophia Anna Balfour*, 1864

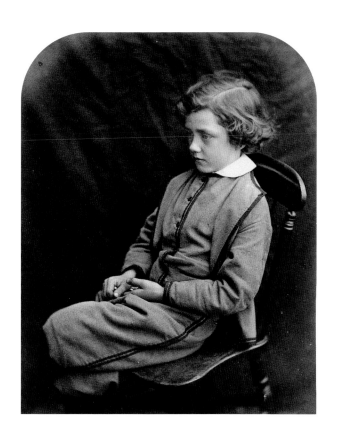

PLATE 55. *Charles Terry*, 1865

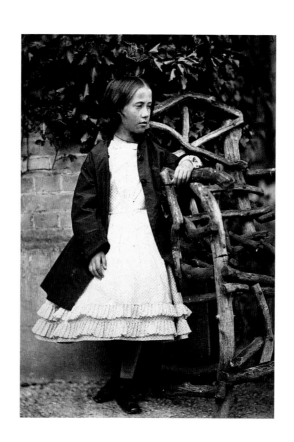

PLATE 56. *Mary Burnett*, 1864

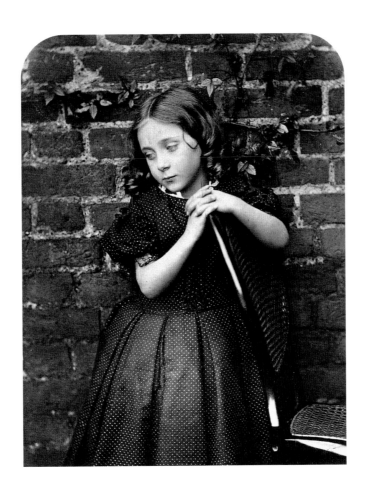

PLATE 57. *Amy Hughes, Daughter of Arthur Hughes, the Artist*, 1863

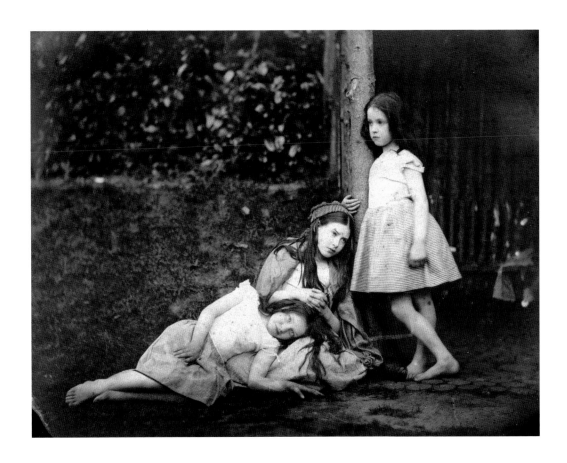

PLATE 58. *Dymphna and Her Sisters*, 1865

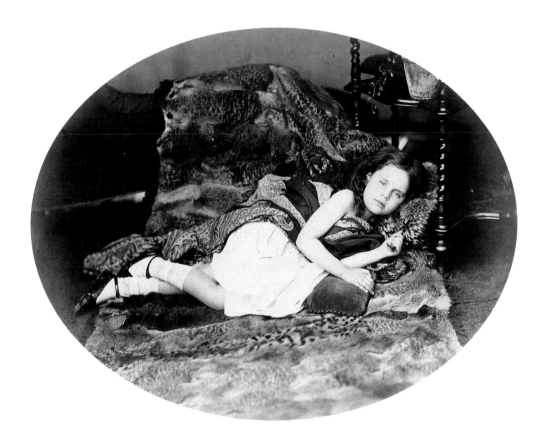

PLATE 59. *Irene MacDonald at Elm Lodge*, 1863

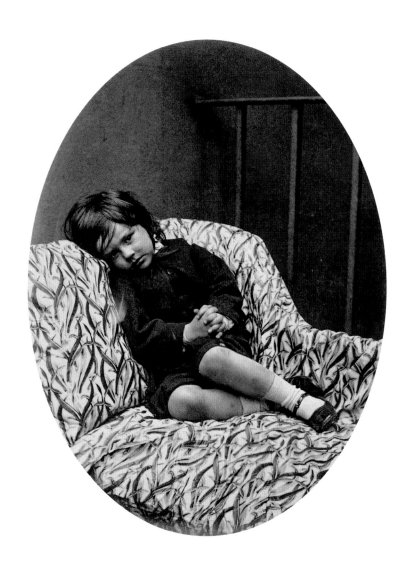

PLATE 60. *James "Jemmie" Sant*, 1866

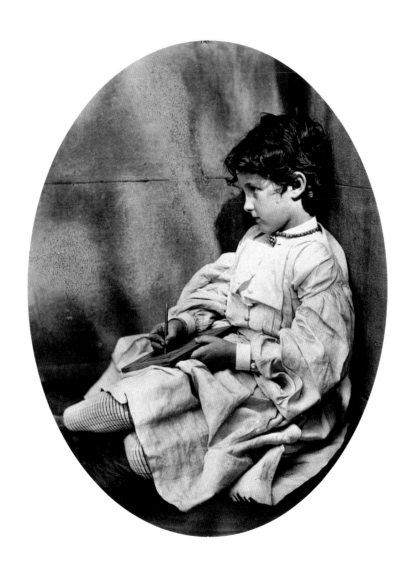

PLATE 61. *Effie Millais*, 1865

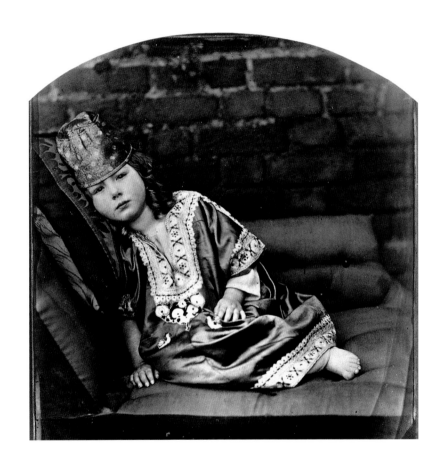

PLATE 62. *Agnes Hughes (Dressed as an Indian)*, 1863

PLATE 63. *Wickliffe Taylor*, 1863

PLATE 64. *Elizabeth "Lizzie" Wilson Todd*, 1865

PLATE 65. *Aileen Wilson Todd*, 1865

PLATE 66. *Emily "Emmie" Drury*, 1874

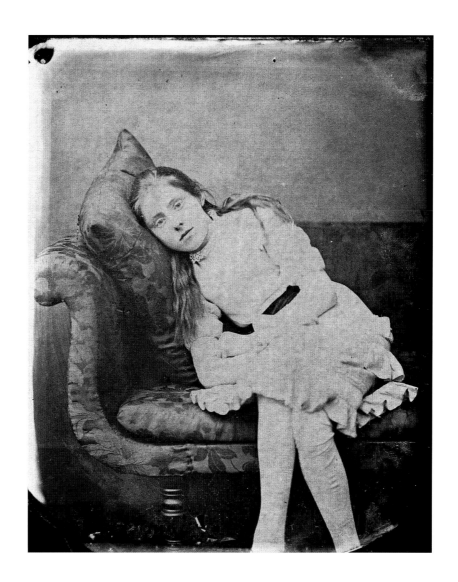

PLATE 67. *Leila Campbell Taylor*, 1879

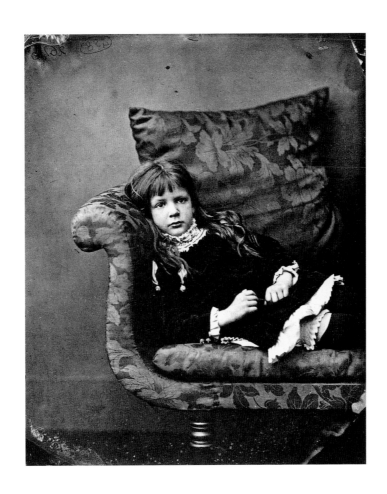

PLATE 68. *Dorothy Kitchin*, 1880

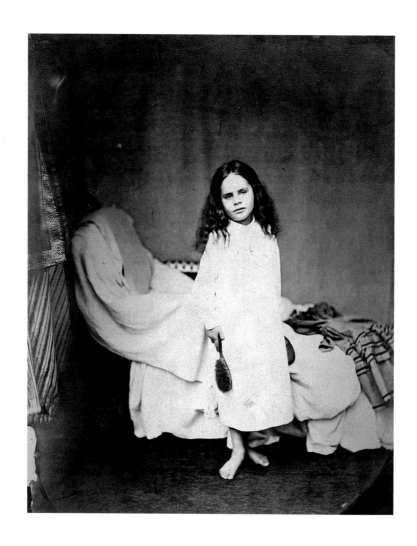

PLATE 69. *Irene MacDonald*, 1863

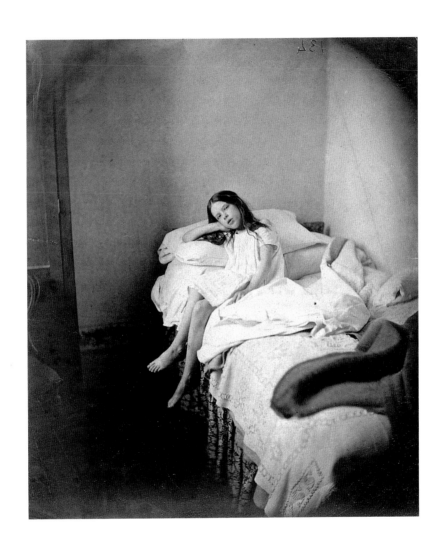

PLATE 70. *Julia Arnold, Seated on Unmade Bed,* ca. 1872

PLATE 71. *Beatrice Hatch*, 1874

PLATE 72. *Charlotte Edith Denman*, 1864

PLATE 73. *Zoë Strong*, 1863

PLATE 74. *Catherine "Katie" Gram Brine,* 1866

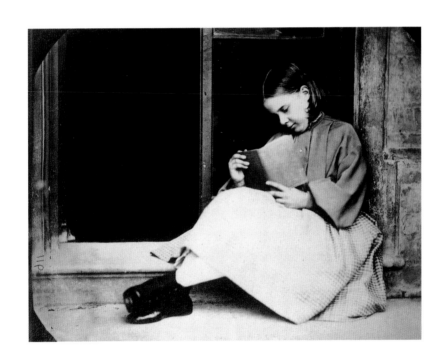

PLATE 75. *Laura Dodgson*, 1862

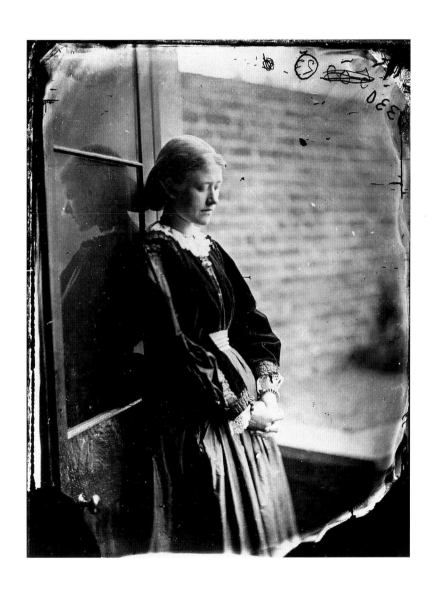

PLATE 76. *Ellen Watts (Ellen Terry)*, 1865

Commentary on the Works by Edward Wakeling

As Dodgson did not give proper titles to the majority of his photographs, most of the following titles are derived from his informal descriptions of his pictures. In the few cases where he did actually title a work, that title is given in quotation marks.

Unless noted otherwise, all works are vintage albumen prints.

The number given in brackets at the end of each caption is taken from Dodgson's own register of his photographic opus. Unfortunately, the register no longer survives, but many of these numbers appear in indexes to his photographic albums and on the verso of surviving prints. The numbers were assigned retrospectively in 1875, nineteen years after he began taking photographs. The numbers were assigned chronologically, but Dodgson made some errors as he attempted to reconstruct his photographic work from diary entries and notes. One complete year was omitted, and he later assigned a different system for about one hundred photographs, giving each number the prefix "P." Where an image number is unknown, a likely range is provided instead.

PLATE 1 (Frontispiece). *Charles Lutwidge Dodgson*, May 1875. 5 $^{9}\!/_{16}$ x 4 $^{1}\!/_{8}$ in. (14.1 x 10.4 cm). Courtesy of the National Museum of Photography, Film, and Television, Bradford, England.

This is an assisted self-portrait of Dodgson taken in his rooftop studio at Christ Church, Oxford. From his first year of photography in 1856 until 1876, when he was forty-four years of age, Dodgson took about fifteen self-portraits and was also the subject of portraits by his friend Reginald Southey (in 1855 and 1856), by Oscar Rejlander (in 1863), and by Dr. George Wallich (in 1866). The leather chair seen here was also used for a series of important sitters, including John Ruskin (1819–1900); Edward King (1830–1910), bishop of Lincoln; Mrs. Julia Arnold, née Sorrell (1827–1888); Edward Francis Sampson (1848–1918), mathematics tutor at Christ Church; and other friends, all photographed in May and June 1875. Dodgson, age forty-three, looks relaxed and confident. His career at Christ Church was by then well established, and income from the *Alice* books had made him financially comfortable. [2285]

PLATE 2. *Skeleton of* Apteryx australis, June 1857. 5 $^{7}\!/_{16}$ x 4 $^{1}\!/_{16}$ in. (13.8 x 10.3 cm). Gernsheim Collection, Harry Ransom Humanities Research Center, The University of Texas at Austin.

Dodgson, with the help of his Christ Church colleague Reginald Southey (1835–1899), made a photographic record of the skeletons in the Anatomical Museum at Christ Church in June 1857, prior to their being transferred to the new University Museum, which opened in 1860. The skeletal specimens were photographed at the suggestion of Dr. Henry Wentworth Acland (1815–1900), professor of medicine at Oxford, in order to ensure that the ownership remained with Christ Church. Some of these skeletons survive to this day, including this one of the flightless *Apteryx australis*, the brown kiwi bird of New Zealand. [218]

PLATE 3. *Alexandra "Xie" Kitchin*, 12 June 1869. 4 $^{3}\!/_{16}$ x 5 $^{3}\!/_{8}$ in. (10.6 x 13.7 cm). National Gallery of Art, Washington. Gift (Partial and Promised) of Mary and David Robinson, 1995.35.4.

This is one of the earliest photographs of Alexandra "Xie" Rhoda Kitchin (1864–1925), the daughter of Dodgson's colleague Rev. George W. Kitchin, taken when she was five years of age. The sofa was transported to Dodgson's rented studio at Badcock's Yard for the purpose. He photographed a number of sitters on this sofa and even made some assisted self-portraits while reclining on the cushions. [1677]

PLATE 4. *Flora Rankin, Irene MacDonald, and Mary Josephine MacDonald at Elm Lodge*, July 1863. 8 $^{3}\!/_{4}$ x 7 $^{1}\!/_{8}$ in. (22.2 x 18.1 cm). Gilman Paper Company Collection.

Flora Rankin (dates unknown), a friend of the children of novelist George MacDonald, happened to be visiting them when Dodgson arrived with his camera. Here she is photographed with Irene MacDonald (b. 1857) and her sister Mary Josephine (1853–1878). Dodgson noted in his diary on 31 July that he spent several days at Elm Lodge in Hampstead, the home of Mrs.

MacDonald's parents, taking photographs of them and a number of their visitors, but "Flora was the only one . . . particularly worth taking." [982–1049]

PLATE 5. *Rev. Thomas Childe Barker and His Daughter May*, 6 June 1864. 8¹/₁₆ x 6 in. (20.5 x 15.3 cm). Gernsheim Collection, Harry Ransom Humanities Research Center, The University of Texas at Austin.

This photograph of Rev. Thomas Childe Barker (b. 1835), vicar of Spelsbury, and his daughter May (b. 1857) was taken in Dodgson's studio at Badcock's Yard. Dodgson annotated the event in his diary: "Barker arrived with his eldest daughter, May, whom I had begged he would bring over to be photographed. Took three pictures of her. One, with him, looks first rate."[1233]

PLATE 6. *"Captive Princess" (Xie Kitchin Wearing a Crown)*, 26 June 1875. 5⅞ x 4⅛ in. (14.9 x 10.4 cm). Gernsheim Collection, Harry Ransom Humanities Research Center, The University of Texas at Austin.

On 26 June 1875, Dodgson took a number of photographs of the Kitchin children in his Christ Church studio, including the tableau *"St. George and the Dragon"* (pl. 34). In this picture, Xie appears in the same costume she wore in the tableau to portray the damsel in distress. [2319]

PLATE 7. *Alexander Munro, the Sculptor, with His Wife, Mary*, 7 October 1863. 5⁷/₁₆ x 4½ in. (13.8 x 11.4 cm). Gernsheim Collection, Harry Ransom Humanities Research Center, The University of Texas at Austin.

This photograph of Alexander Munro (1825–1871) and his wife, Mary, née Carruthers (d. 1872), was taken long after Dodgson first became acquainted with them. In previous years he had taken many photographs of the sculptures in Munro's London studio. Munro let Dodgson use his studio for photographic sessions and introduced him to many of the artists in his circle. Munro and his wife were visiting their friend Dante Gabriel Rossetti when this picture was made in the garden at Tudor House, 16 Cheyne Walk, Chelsea, London. [1136]

PLATE 8. *Florence Terry*, 12 July 1875. Modern platinum print from original wet-collodion glass negative. 6½ x 8⁷/₁₆ in. (16.5 x 21.5 cm). Musée d'Orsay, Paris.

Florence "Flo" Maude Terry (1856–1896) was photographed in the garden at Henry Holiday's home at Oak Tree House, Hampstead. The photograph was taken on 12 July 1875 but was not included in the presentation album that Dodgson prepared for his host to commemorate a week of constant photographic activity at the Holiday residence. [2373]

PLATE 9. *Xie Kitchin as Penelope Boothby*, 1 July 1876. 6¹/₁₆ x 4¹⁵/₁₆ in. (15.4 x 12.5 cm). Gernsheim Collection, Harry Ransom Humanities Research Center, The University of Texas at Austin.

In this photograph taken in the Christ Church studio, Xie Kitchin is dressed in Georgian costume as Penelope Boothby. The pose is based on Sir Joshua Reynolds's famous portrait of her (fig. 16), later published as a mezzotint by Samuel Cousins. The photograph carries the alternate title *Dolly Varden*, a reference to the coquette in Charles Dickens's novel *Barnaby Rudge* (1841), set in 1780s England. [2423]

PLATE 10. *Brook and Hugh Kitchin*, 5 July 1876. 6 x 5 in. (15.2 x 12.7 cm). Collection of Prentice and Paul Sack.

Brook Taylor Kitchin (1869–1940) and Hugh Bridges Kitchin (1867–1945), two of Xie Kitchin's brothers, were photographed in Dodgson's Christ Church studio. Dodgson noted that on this occasion he told the boys and their sister the story of the beggar-maid who became the bride of King Cophetua, a mythical African king—a legend made popular by Alfred, Lord Tennyson's 1842 poem "The Beggar-Maid." [2428]

PLATE 11. *Xie Kitchin and Her Brother George Herbert*, 19 April 1873. Modern gold-toned printing-out paper print from original wet-collodion glass negative. 5⅛ x 6 in. (13 x 15.2 cm). Private collection.

Xie and her brother George Herbert (b. 1865) are draped in Indian shawls and carefully positioned in a corner of the Christ Church rooftop studio for this relaxed pose. Dodgson was acquainted with several families who had connections with India and borrowed the shawls to add interest to this and other photographs taken around this time, including one he made the same day, which he titled *"High Caste"* (pl. 51). [2093]

PLATE 12. *Marion "Polly" Terry and Her Sister Florence "Flo,"* 14 July 1865. 4¹⁵/₁₆ x 3¾ in. (12.6 x 9.5 cm). Gernsheim Collection, Harry Ransom Humanities Research Center, The University of Texas at Austin.

PLATE 13. *Florence Maude Terry*, 14 July 1865. 4 15/16 x 3 3/4 in. (12.6 x 9.6 cm). Gernsheim Collection, Harry Ransom Humanities Research Center, The University of Texas at Austin.

Marion "Polly" Terry (1854–1930) and her sister Florence were photographed at the Terry family's home, 92 Stanhope Street, London. Both became actresses, following in the footsteps of their well-known older sisters, Kate and Ellen Terry. [1341 and 1340]

PLATE 14. *Arthur Hughes, the Artist, and His Daughter Agnes*, 12 October 1863. 9 1/2 x 7 1/8 in. (24.1 x 18.8 cm). Gernsheim Collection, Harry Ransom Humanities Research Center, The University of Texas at Austin.

After visiting his friend the novelist George MacDonald (1824–1905) on 12 October 1863, Dodgson noted in his diary: "Mr. A. Hughes came over to be photographed with his children. . . . Got a splendid picture of him with Agnes." The photograph of Arthur Hughes (1830–1915) and his daughter Agnes (1859–1945) was taken in the garden of the MacDonald home at 12 Earl's Terrace, Kensington, London. Earlier in the year, Dodgson had purchased a painting from Hughes titled *The Lady with the Lilacs*, which hung in his rooms at Christ Church. [1177]

PLATE 15. *Rev. James Langton Clarke with His Son, Charles Langton*, September 1864. 5 7/8 x 4 7/8 in. (14.9 x 12.4 cm). The Art Institute of Chicago. Gift of Mrs. John W. Taylor, Mrs. Winthrop M. Robins, Jr., and Mrs. Fred D. Sauter, from the Estate of Frances Hooper, 1987.211.4.

James Langton Clarke (1833–1916), M.A., Durham, curate of Whitburn from 1858 to 1860, married Frances Mary Harrison, daughter of the railway engineer Thomas Elliott Harrison, in 1857. Their son, Charles Langton "Robin," was born in 1858. This photograph was taken between 19 and 29 September 1864. In his spare time, Langton Clarke was an inventor, applying for six different patents between 1863 and 1885. He officiated at the christening of Dodgson's cousin Mary Dorothea Wilcox in October 1859. [P50–P100]

PLATE 16. *George MacDonald and His Daughter Lily "Lilia" Scott MacDonald*, 14 October 1863. 8 1/8 x 9 11/16 in. (20.6 x 24.6 cm). Gernsheim Collection, Harry Ransom Humanities Research Center, The University of Texas at Austin.

After photographing George MacDonald and his daughter Lily "Lilia" Scott MacDonald (1852–1891), Dodgson wrote in his diary on 14 October 1863: "Took a large picture of Mr. MacDonald and Lily. Went to Bond Street in a Hansom with Greville to leave the negatives." The previous week had been spent taking photographs of the MacDonald family and invited friends at their home at 12 Earl's Terrace, Kensington, London. MacDonald, a Scotsman and Congregationalist minister, was the author of the fairy stories *At the Back of the North Wind* and *The Princess and the Goblin*, both of which were illustrated by Arthur Hughes (pl. 14). [1183]

PLATE 17. *Margaret Frances Langton Clarke*, September 1864 6 x 4 15/16 in. (15.2 x 12.6 cm). The Art Institute of Chicago. Gift of Mrs. John W. Taylor, Mrs. Winthrop M. Robinson, Jr., and Mrs. Fred D. Sauter, from the Estate of Frances Hooper, 1987.211.3.

Margaret Frances Langton Clarke (b. 1860), the eldest daughter of Rev. James Langton Clarke, was photographed at Whitburn, Sunderland, between 19 and 29 September 1864. Dodgson was visiting his Wilcox cousins at Whitburn and noted in his diary on 2 October 1864: "During my stay, I took a good many photographs—of the Wilcoxes, the Langton Clarkes." [P50–P100]

PLATE 18. *Florence Maude Terry as Cinderella*, 17 July 1865. Modern platinum print from original wet-collodion glass negative. 3 1/8 x 4 5/16 in. (8 x 11 cm). Musée d'Orsay, Paris.

PLATE 19. *Florence Maude Terry*, 17 July 1865. Modern platinum print from original wet-collodion glass negative. 7 7/8 x 9 13/16 in. (20 x 25 cm). Musée d'Orsay, Paris.

These two photographs were taken in the garden of the Terry family's home in London. Dodgson wrote in his diary on 17 July 1865: "At the Terrys, took Flo as 'Cinderella,' and one or two others, packed and brought all to the Old Hummums, and spent the evening at Putney." Florence Terry went on to become a renowned actress, following in the footsteps of her famous sisters. Dodgson watched her career with interest and attended many of her performances. [1351?]

PLATE 20. *"The Prettiest Doll in the World,"* 5 July 1870. 7 3/4 x 5 13/16 in. (19.7 x 14.8 cm). Gilman Paper Company Collection.

Xie Kitchin was photographed in rags in a picture that Dodgson titled *"The Prettiest Doll in the World."* The title is a line from

"The Lost Doll," a poem by Rev. Charles Kingsley. Kingsley (1819–1875) was the author of *The Water-Babies* (1862), a Victorian fantasy about the working conditions of the poor. The photograph was taken in Dodgson's rented studio at Badcock's Yard, not far from Christ Church. [1893]

PLATE 21. *Alice Liddell as "The Beggar-Maid,"* Summer 1858. 6⅜ x 4¼ in. (16.2 x 10.8 cm). Gilman Paper Company Collection.

This famous picture of Alice Pleasance Liddell (1852–1934) as "The Beggar-Maid" was taken in the Deanery garden at Christ Church. Alice was the daughter of Henry George Liddell (1811–1898), the dean of Christ Church. She is dressed in rags, with her hand cupped, as if begging for money. Dodgson had made an earlier version of Alice in this guise, in June 1857, and devised several versions of this work through different croppings and hand-coloring. [354]

PLATE 22. *Annie Coates, Daughter of William and Isabella Coates, Croft,* August 1857. 6 x 4¹⁵⁄₁₆ in. (15.3 x 12.5 cm). Gernsheim Collection, Harry Ransom Humanities Research Center, The University of Texas at Austin.

Annie Coates (dates unknown) was the daughter of Isabella and William Coates, a poulterer and grocer at Croft. Little is known about her. Dodgson photographed her twice in August 1857; in the other portrait she looks directly at the camera, with her hair loose over her shoulders. The humble background of this photograph has misled people into thinking that she was a servant at the rectory, but her father was a tradesman, a step above the serving class. [287½]

PLATE 23. *Sarah Hobson,* August 1857. 4¹⁵⁄₁₆ x 3⅞ in. (12.6 x 9.9 cm). Courtesy of the National Museum of Photography, Film, and Television, Bradford, England.

Sarah Hobson (b. 1852) was the eldest daughter of Henry Hobson (1819–1873), the schoolmaster at the Croft National School. The school was built during the time of the Dodgsons' occupancy of the rectory at Croft and received substantial financial support from the Dodgson family. The photograph was taken in the rectory garden. [280⅔]

PLATE 24. *Alice Liddell Feigning Sleep, a Hat by Her Side,* Spring 1860. Modern gold-toned printing-out paper print from original wet-collodion glass negative. 4¹⁵⁄₁₆ x 6 in. (12.6 x 15.2 cm). Private Collection.

Alice Liddell lies on a rug in the Deanery garden, with a blanket serving as a partial backdrop against the sandstone wall. Alice's head is carefully posed on a cushion so that her face can be seen. The photograph was taken during the spring of 1860, when Alice was eight, two years before the boating trip that would result in *Alice's Adventures in Wonderland*. [537]

PLATE 25. *Alice, Lorina, Harry, and Edith Liddell,* May or June 1860. 5¹¹⁄₁₆ x 7⅜ in. (14.5 x 18.8 cm). Private Collection.

The Liddell children, Alice, Lorina, Harry, and Edith, sat for Dodgson in the Deanery garden at Christ Church. Sporting a cricket bat, Edward Henry "Harry" Liddell (1847–1911), the dean's eldest son, was home from school when this photograph was taken. Dodgson had tutored him in mathematics and made him one of his earliest photographic subjects. [547]

PLATE 26. *"Open Your Mouth and Shut Your Eyes,"* July 1860. Modern gold-toned printing-out paper print from original wet-collodion glass negative. 10 x 8 in. (25.4 x 20.3 cm). Private Collection.

Posed in the Deanery garden at Christ Church, the three Liddell sisters enact the child's game "Open Your Mouth and Shut Your Eyes." The painter William Mulready had exhibited a picture of the same title at the South Kensington Museum in 1856, which Dodgson visited at least twice before arranging this image. From left to right, Edith Mary (1854–1876) sits on the table holding the plate of cherries; Lorina Charlotte (1849–1930) suspends the fruit, her left hand probably steadied by some unseen prop; and Alice is about to taste her surprise treat. [611]

PLATE 27. *Maria White, Niece of the Porter at Lambeth Palace,* 11 July 1864. 4¹⁵⁄₁₆ x 3⅞ in. (12.6 x 9.9 cm). Gernsheim Collection, Harry Ransom Humanities Research Center, The University of Texas at Austin.

Maria White was the niece of a porter at Lambeth Palace, the London residence of the Archbishop of Canterbury. Dodgson set up his camera there for a photographic interval that lasted several days in July 1864. Seated beside one of the stone buildings of the palace, Maria holds a geranium (genus *Pelargonium*), which symbolized "gentility" in the Victorian language of flowers. Dodgson noted that she "sat capitally" for this picture. [P9]

PLATE 28. *Ella Chlora Monier-Williams,* May 1866. 5⅞ x 4⅞ in. (14.9 x 12.4 cm). Private collection.

Ella Chlora Faithfull Monier-Williams (1859–1954) was the only daughter of Monier Monier-Williams, Boden Professor of Sanskrit at Oxford, and his wife, Julia, née Faithfull. Dodgson took several photographs of Ella and her brothers in May 1866. Posing a child in the corner of a sofa, with head resting on hands, was Dodgson's way of keeping the young sitter still during the exposure of the glass plate; the result nonetheless was a remarkably relaxed, natural-looking image. [1461–1483]

PLATE 29. *Ella Chlora Monier-Williams and a Younger Brother*, May 1866. 5 ¹¹⁄₁₆ x 4 ⁵⁄₁₆ in. (14.8 x 11 cm). San Francisco Museum of Modern Art. Purchased through a gift of Shawn and Brook Byers, Elaine McKeon, Michael Wilson and Accessions Committee Fund and the Herbert and Nannette Rothschild Memorial Fund, in memory of Judith Rothschild.

This photograph of Ella and a younger brother, either Clive, Stanley, or Outram, was taken in Dodgson's studio at Badcock's Yard, St. Aldates Street, Oxford. [1461–1483]

PLATE 30. *Annie and Henry Rogers*, June 1861. 5 ⁵⁄₁₆ x 7 ¹¹⁄₁₆ in. (15.1 x 19.5 cm). Dr. M. A. T. Rogers.

Annie Mary Ann Henley Rogers (1856–1937) and her brother, Henry Reynolds Knatchbull Rogers (1858–1876), were two children of James Edwin Thorold Rogers, professor of political economy at Oxford, and his wife, Anne Susanna Charlotte, née Reynolds. Here Dodgson employs his usual strategy of posing the young Rogers children in the corner of a sofa to keep them comfortable and still. Henry apparently moved his head a little, causing some blurring of his face. [958–973]

PLATE 31. *Annie and Henry Rogers*, July 1863. 5 ⁷⁄₁₆ x 4 ½ in. (13.8 x 11.4 cm). Dr. M. A. T. Rogers.

Although this photograph was taken two years after pl. 30, the bond between brother and sister is still evident in the composition. Henry went to Westminster School in 1872 and by 1876 was school captain, but he died tragically the same year at age eighteeen. [958–973]

PLATE 32. *Annie Rogers*, 3 July 1863. 8 x 6 in. (20.3 x 15.2 cm). Dr. M. A. T. Rogers.

Annie Rogers, seen here in a petticoat and frill-edged drawers, was a frequent photographic model for Dodgson at this time, posing in ordinary dress as well as in historical costumes. She

later became an avid supporter of women's rights and education for women, remaining unmarried. [958–973]

PLATE 33. *The Fair Rosamond*, 3 July 1863. 8 ⅞ x 7 in. (22.5 x 17.8 cm). Dr. M.A.T. Rogers.

Mary Jackson poses as Rosamond (left), with Annie Rogers as Queen Eleanor. Mary (b. 1854?) was the daughter of Dr. Robert Jackson (1810–1887), a physician in Oxford, and Annie was the daughter of Professor James Edwin Thorold Rogers. The photograph was taken in Dodgson's studio at Badcock's Yard. Rosamond Clifford (d. 1176) was the mistress of King Henry II, and legend has it that he built a labyrinth to conceal her from his wife, Queen Eleanor. However, the queen discovered her and had her put to death. She was buried at Godstow nunnery, not far from where the Liddell sisters landed after their immortal boat trip with Dodgson on 4 July 1862. [974]

PLATE 34. *"St. George and the Dragon,"* 26 June 1875. 4 ⅝ x 5 ⅞ in. (11.7 x 14.9 cm). Gilman Paper Company Collection.

Getting a large rocking horse up into Dodgson's Christ Church rooftop studio must have been quite a feat. All four Kitchin children play a part in this mythological scene: Brook Taylor, on the rocking horse, poses as St. George; George Herbert and Hugh Bridges are, respectively, the defeated soldier and the dragon (draped with a leopard skin); and Xie portrays the damsel. [2316]

PLATE 35. *Marion "Polly" Terry*, 12 July 1875. Modern platinum print from original wet-collodion glass plate negative. 6 ½ x 8 ⁷⁄₁₆ in. (16.5 x 21.5 cm). Musée d'Orsay, Paris.

Dressed in chain mail that belonged to the artist and illustrator Henry Holiday, Marion "Polly" Terry posed as James Fitz-James, the hero of Sir Walter Scott's poem *The Lady of the Lake*. The photograph was taken at Holiday's home, Oak Tree House, Hampstead, where Dodgson was a guest for a week. He took photographs of the family and a string of visitors who came to sit before his camera, including Evelyn Dubourg, posed in the same costume but identified as Joan of Arc, and Rose Lawrie as Sir Galahad. [2370]

PLATE 36. *"Andromeda,"* 15 July 1865. 5 ⅞ x 4 ¹⁵⁄₁₆ in. (15 x 12.5 cm). The Alfred C. Berol Collection, The Fales Library, New York University.

When he saw her portraying a sea nymph in a performance of *The Tempest*, Dodgson called Elizabeth "Kate" Terry (1844–1924) "one of the most beautiful living pictures I ever saw." Here he photographed her, along with her sister Ellen Alice Terry, Mrs. George Frederick Watts (1847–1928), thus capturing two of the brightest stars of the London stage. Kate represents Andromeda, her raised arms tied with a silken cord, and next to her is Ellen, standing in for Perseus. [1346?]

PLATE 37. *Florence Terry Dressed as a Turk*, 12 July 1875. Modern platinum print from original wet-collodion glass plate negative. 6½ x 8⁷⁄₁₆ in. (16.5 x 21.5 cm). Musée d'Orsay, Paris.

On 12 July 1875 Dodgson wrote in his diary: "A grand day of photos, did the Du Maurier children, and the Terrys; Polly in armour, and as 'Dora,' and Florence as a Turk." This photograph of Florence was taken at the home of Henry Holiday in Hampstead during the week he took numerous pictures there. [2371]

PLATE 38. *Ellen Terry and Her Sister Florence*, 13 July 1865. Modern platinum print from original wet-collodion glass plate negative. 4¹⁵⁄₁₆ x 5⅞ in. (12.5 x 15 cm). Musée d'Orsay, Paris.

Ellen Alice Terry and her sister Florence posed for Dodgson at the Terry family home in London. Ellen made her debut on the London stage in *The Winter's Tale* at age nine—Florence's exact age in this picture. Dodgson's camera is uncharacteristically placed at a high vantage point, looking down at them. [1331]

PLATE 39. *John Everett Millais, His Wife, and Two of Their Daughters*, 21 July 1865. 5 x 3¹¹⁄₁₆ in. (12.7 x 9.4 cm). Gernsheim Collection, Harry Ransom Humanities Research Center, The University of Texas at Austin.

The renowned Victorian artist John Everett Millais (1829–1896), his wife, Euphemia "Effie," née Gray (1828–1897), and two of their daughters, Effie Gray (1858–1912) and Mary Hunt (1860–1944), pose at the window of their home, 7 Cromwell Place, London. The composition indicates a close family relationship, with young Effie the only one to show interest in the photographer. [1363]

PLATE 40. *Reginald Southey and Skeletons*, June 1857. 6⁹⁄₁₆ x 5⁷⁄₁₆ in. (16.7 x 13.8 cm). Courtesy of the National Museum of Photography, Film, and Television, Bradford, England.

Reginald Southey studied science and anatomy at Christ Church and went on to become an eminent surgeon at St. Bartholomew's Hospital, London. A proficient amateur photographer, he taught Dodgson the rudiments of the "black art." Here he poses with specimens from the Christ Church Anatomical Museum in a literal illustration of comparative anatomy. Dodgson showed the photograph to Tennyson, who remarked that the young monkey's skull was quite human in shape—this, two years before Charles Darwin's publication of *The Origin of Species*. In one of his albums Dodgson appended to the image lines from Tennyson's poem "The Vision of Sin":

> *You are bones, and what of that?*
> *Every face, however full,*
> *Padded round with flesh and fat,*
> *Is but modell'd on a skull.*
> [219]

PLATE 41. *Xie Kitchin Reclining in a Cane Chair*, 1 July 1876. Modern platinum print from original wet-collodion glass plate negative. 8½ x 6⁹⁄₁₆ in. (21.6 x 16.7 cm). Musée d'Orsay, Paris.

In this photograph, Xie Kitchin wears the same costume that she used as Penelope Boothby (see pl. 9), with the addition here of a Chinese umbrella. It was taken in Dodgson's Christ Church rooftop studio. Dodgson's cousin Harry Wilcox traveled to the Far East, visiting India and China, and brought back a number of artifacts that may have been used in this and other photographs. [2422]

PLATE 42. *Xie Kitchin*, May or June 1872. 4⁷⁄₁₆ x 6¹¹⁄₁₆ in. (11.3 x 17 cm). Collection Carla Emil and Rich Silverstein.

Xie Kitchin was one of Dodgson's favorite photographic models, sitting for him at least fifty times in various costumes and poses over a period of eleven years. She was the daughter of one of Dodgson's colleagues at Christ Church, George William Kitchin (1827–1912), a lecturer in modern history, former head of the Twyford School, and later dean of Winchester. The photograph was taken in Dodgson's Christ Church rooftop studio. [2044]

PLATE 43. *"Rosy Dreams and Slumbers Light,"* 12 June 1873. 4¾ x 5¹¹⁄₁₆ in. (12 x 14.5 cm). Musée d'Orsay, Paris.

Dodgson's diary records that he took this photograph of Xie Kitchin on 12 June 1873. He gave the image two different titles: *"Where Dreamful Fancies Dwell"* and *"Rosy Dreams and*

Slumbers Light." The latter title was probably taken from Sir Walter Scott's poem "L'envoy": "To all, to each, a fair good-night, And pleasing dreams, and slumbers light!" [2144]

PLATE 44. *"Sleepless,"* 18 May 1874. 5⅛ x 4 in. (13.1 x 10.2 cm). Private collection.

Dodgson's diary entry for 22 June 1874 noted: "On the 16th [of May] Holiday arrived on a visit to me. On the 18th he fetched Xie Kitchin to be photographed, and I did a large one, full length lying on the sofa in a long night-gown, which Holiday arranged, about the best I have ever done of her." This photograph, which he titled *"Sleepless,"* was taken at the same time. [2250]

PLATE 45. *"Off Duty,"* 14 July 1873. 7⅞₁₆ x 10¹⁄₁₆ in. (20.2 x 25.5 cm). Musée d'Orsay, Paris.

PLATE 46. *"On Duty,"* 14 July 1873. 7½ x 5¹³⁄₁₆ in. (19 x 14.7 cm). Gernsheim Collection, Harry Ransom Humanities Research Center, The University of Texas at Austin.

On 14 July 1873, Dodgson wrote: "Took Xie in Chinese dress (two positions)." One, which he titled *"On Duty,"* shows an alert Xie Kitchin holding a fan and wearing a cap and shoes, resting atop chests of China tea. In the other she is more relaxed. Her cap and shoes have been taken off, and Xie leans against the tea chests in a pose Dodgson titled *"Off Duty."* The Chinese costume is probably authentic, borrowed from one of the Oxford museums. [2155 and 2156]

PLATE 47. *"Little Vanity,"* 14 March 1874. Modern gold-toned printing-out paper print from original wet-collodion glass plate negative. 6 x 5 in. (15.2 x 12.7 cm). Private collection.

Dodgson taught the rudiments of photography to a colleague at Christ Church, Robert Baynes. One of the pictures he took to demonstrate both the process and the art of composition was this one of Julia Frances Arnold (1862–1908) as *"Little Vanity."* Julia wears a long white flowing costume while standing before a looking-glass. A niece of the poet Matthew Arnold, Julia grew up to marry Leonard Huxley and become the mother of Thomas and Aldous Huxley. [2216]

PLATE 48. *"Penitence,"* 23 March 1874. Modern platinum print from original wet-collodion glass plate negative. 8⅝₁₆ x 6½ in. (21.7 x 16.5 cm). Musée d'Orsay, Paris.

Xie Kitchin, wearing a white nightgown, with hands clasped and eyes looking upward, posed for Dodgson in a photograph he titled *"Penitence."* It was taken in his Christ Church studio. [2224]

PLATE 49. *"Xie Kitchin as Dane,"* 14 May 1873. 5½ x 4 in. (14.2 x 10.2 cm). Collection of Mark and Catherine Richards.

Soon after this photograph of Xie Kitchin was taken, Dodgson's friend Alice Emily Donkin made an oil painting based on the image, which she titled *Waiting to Skate.* It hung in Dodgson's rooms at Christ Church until his death, afterward going to the Kitchin family. This was one of Dodgson's favorite photographs of Xie, and many prints survive. [2132]

PLATE 50. *"Tuning,"* July 1876. 8¼ x 6⅞₁₆ in. (20.9 x 15.7 cm). Gernsheim Collection, Harry Ransom Humanities Research Center, The University of Texas at Austin.

Dodgson gave the title *"Tuning,"* to this photograph of Xie Kitchin, who was an accomplished violinist. He achieved the steady pose by having Xie stand with her back leaning against the wall, resting the tip of her bow on the wall (as indicated by the slight shadow). The photograph was taken in his Christ Church studio. [2425]

PLATE 51. *"High Caste,"* 19 April 1873. 5⁷⁄₁₆ x 3⁹⁄₁₆ in. (13.2 x 9.1 cm). Collection of Mimi and Peter Haas.

This photograph of Xie Kitchin was taken in Dodgson's Christ Church rooftop studio. He also photographed Xie's brother George Herbert in the same position. The Indian shawl was no doubt borrowed for the occasion. [2092]

PLATE 52. *Xie Kitchin (in Greek Dress),* 12 June 1873. 7⁹⁄₁₆ x 5¾ in. (19.2 x 13.4 cm). Courtesy Robert Koch Gallery.

Amy Price, the wife of Professor Bartholomew "Bat" Price (1818–1898) of Pembroke College, Oxford, made this Greek dress for Dodgson to use in his photographs. Xie Kitchin wears the costume in this picture taken in his Christ Church studio. Several photographs survive of other girls wearing the dress. Classical costumes of this kind were common in Victorian paintings, inspiring Dodgson to use them in this and other photographs. [2144½]

PLATE 53. *Ella Chlora Monier-Williams*, May 1866. 5 1/16 x 3 15/16 in. (12.9 x 10 cm). Gernsheim Collection, Harry Ransom Humanities Research Center, The University of Texas at Austin.

Dodgson noted in his diary on 24 May 1866: "Mrs. Williams brought over the little Ella to be photographed, of whom I took two excellent negatives," and on 29 May 1866 he wrote: "Photographed Ella Williams." This photograph of Ella was taken at his Badcock's Yard studio on one of these two dates. [1461–1483]

PLATE 54. *Ella Sophia Anna Balfour*, 5 July 1864. 4 15/16 x 3 3/4 in. (12.6 x 9.5 cm). Gernsheim Collection, Harry Ransom Humanities Research Center, The University of Texas at Austin.

Ella Sophia Anna Balfour (1854–1935) was photographed at Lambeth Palace, London. She was the daughter of James Leycester Balfour and his wife, Sophia, née Cathcart. Mr. Balfour had been head teacher at the Kepler Grammar School in Durham. By the time this picture was taken, Mrs. Balfour was a widow and ran a small school at Roker. [1285]

PLATE 55. *Charles Terry*, 14 July 1865. 4 1/8 x 3 1/2 in. (10.4 x 8.9 cm). Gernsheim Collection, Harry Ransom Humanities Research Center, The University of Texas at Austin.

This photograph of Charles "Charlie" John Arthur Terry (1858–1933), a younger brother of the actresses Ellen and Kate Terry, was taken at their London home. Like his sisters, Charlie had a career in the theater, but worked as a stage and business manager. Dodgson was a frequent visitor to the Terry family home and watched the progress of the children with great interest. [1366]

PLATE 56. *Mary Burnett*, 17 August 1864. 5 3/8 x 3 13/16 in. (13.6 x 9.7 cm). Gernsheim Collection, Harry Ransom Humanities Research Center, The University of Texas at Austin.

Dodgson was at Freshwater, Isle of Wight, from 26 July to 19 August 1864, taking a holiday with his camera. On 17 August 1864 he wrote in his diary: "Mr. and Mrs. Burnett came with me to Farringford, with the two children, Frank and Mary, of whom I took pictures." Mary Burnett (b. 1853) was the daughter of Robert French Burnett (d. 1872) and his wife, Harriet, née Jeaffreson. Farringford was the home of Alfred, Lord Tennyson, and was near Dimbola Lodge, the home of Julia Margaret Cameron. [P47]

PLATE 57. *Amy Hughes, Daughter of Arthur Hughes, the Artist*, 12 October 1863. 4 15/16 x 3 7/8 in. (12.5 x 9.8 cm). Gernsheim Collection, Harry Ransom Humanities Research Center, The University of Texas at Austin.

This photograph of Amy Hughes (1857–1915) was taken in the garden at the home of the MacDonald family, who were living at 12 Earl's Terrace, Kensington, London. Amy studied art with her father and produced several competent oil paintings. She married John Greville Chester, a minor church official, in 1883. [1172]

PLATE 58. *Dymphna and Her Sisters*, July 1865. 8 13/16 x 6 13/16 in. (22.4 x 17.3 cm). Joseph Brabant Collection, Thomas Fisher Rare Book Library, University of Toronto.

Dodgson wrote on 25 July 1865: "Went down to Windsor, with camera etc. and drove over to the Ellises at Cranbourne, where I found they were able to house me, so I got the camera out, and began at once with a good picture of Dymphna." The following day he recorded, "Photographs all day." This picture shows three of the four daughters of Rev. Conyngham Ellis (1817–1891), rector of Cranbourne, near Windsor, and his wife, Sophia Ellis, née Babington. The daughters were Frances Dymphna Harriet (1854–1930), Mary (b. 1856), Bertha S. (b. 1858), and Katherine "Kate" (b. 1860). [1379–1404]

PLATE 59. *Irene MacDonald at Elm Lodge*, July 1863. 6 7/8 x 8 7/8 in. (17.5 x 22.5 cm). Courtesy Robert Koch Gallery.

Dodgson's photograph of Irene MacDonald in a white dress, lying on oriental rugs and blankets, was taken during one of his visits to the home of the MacDonald family. Irene is shown reclining, a common pose that Dodgson used with many of his younger sitters. [1008]

PLATE 60. *James "Jemmie" Sant*, 26 July 1866. 5 1/16 x 3 3/4 in. (12.8 x 9.6 cm). Gernsheim Collection, Harry Ransom Humanities Research Center, The University of Texas at Austin.

James "Jemmie" Sant (b. 1862), the four-year-old son of the artist James Sant (1820–1916), was photographed at the Sant family home, 2 Fitzroy Square, London. Dodgson photographed most of the family at various times. James Sant became a portrait painter and exhibited at the Royal Academy from 1840 to 1904. In 1872 he was appointed portrait painter to Queen Victoria. He married Eliza Thomson (1833–1907) in 1851. They had six children, Jemmie being their fifth. [1523]

PLATE 61. *Effie Millais*, 21 July 1865. 4 15/16 x 3 3/4 in. (12.6 x 9.5 cm). Gernsheim Collection, Harry Ransom Humanities Research Center, The University of Texas at Austin.

Effie Gray Millais (1858–1912) was the daughter of the artist John Everett Millais and his wife, Euphemia "Effie," née Gray. The child was photographed at the Millais home at 7 Cromwell Place, London. [1359]

PLATE 62. *Agnes Hughes (Dressed as an Indian)*, 12 October 1863. 4 3/4 x 5 1/8 in. (12 x 13 cm). Gernsheim Collection, Harry Ransom Humanities Research Center, The University of Texas at Austin.

Agnes Hughes was the daughter of the artist Arthur Hughes and his wife, Tryphena, née Foord. The photograph was taken in the garden of the MacDonald family's Kensington home. Agnes studied art with her father and married John Henry White (later Hale-White), a railway-design engineer, in 1891. [1173]

PLATE 63. *Wickliffe Taylor*, 3 October 1863. 5 1/16 x 4 in. (12.9 x 10.2 cm). Gernsheim Collection, Harry Ransom Humanities Research Center, The University of Texas at Austin.

Dodgson visited the home of the dramatist Tom Taylor (1817–1880) at Wandsworth, London, where he was given the use of a cellar as a darkroom and the conservatory as a studio. Taylor's young son, Wickliffe, was not a patient sitter, so it took some time for Dodgson to settle him down before he could take this seemingly relaxed portrait of the boy. [1116]

PLATE 64. *Elizabeth "Lizzie" Wilson Todd*, 4 September 1865. 4 7/8 x 3 7/8 in. (12.4 x 9.9 cm). Gernsheim Collection, Harry Ransom Humanities Research Center, The University of Texas at Austin.

Elizabeth "Lizzie" Jane Wilson Todd (1856–1931) was the daughter of Sir William Henry Wilson Todd (1828–1910) and Jane Marian Rutherford, née Todd, of Halnaby Hall, Darlington. Mrs. Wilson Todd was the only daughter and heiress to the estate of John Todd, who had purchased Halnaby Hall from Sir John Milbanke in 1843. Her husband assumed her family name in order to claim the inheritance. The photograph was taken at Croft Rectory, not far from Halnaby Hall. [1415]

PLATE 65. *Aileen Wilson Todd*, 4 September 1865. 4 15/16 x 3 7/8 in. (12.5 x 9.9 cm). Gernsheim Collection, Harry Ransom Humanities Research Center, The University of Texas at Austin.

Aileen Frances Mary Wilson Todd (1859?–1937) was the younger sister of Elizabeth "Lizzie" Wilson Todd (pl. 64). In Victorian times, it was common for sisters to wear identical dresses. This photograph was taken at Croft Rectory. Aileen married Captain James Stevenson Twysden in 1889. [1416]

PLATE 66. *Emily "Emmie" Drury*, 16 June 1874. 6 1/4 x 4 3/4 in. (15.9 x 12.1 cm). Private collection.

Dodgson's diary entry for 22 June 1874 states: "On the 16th (Tu) Mrs. Drury brought her 3 girls, and Miss Sampson, for the day. I photographed and fed them, and treated them to the Horticultural Fete." He took this photograph of the youngest sister, Emily "Emmie" Henrietta (1864–1930). [2275]

PLATE 67. *Leila Campbell Taylor*, 19 July 1879. 4 7/8 x 6 in. (12.4 x 15.3 cm). Courtesy of the National Museum of Photography, Film, and Television, Bradford, England.

On 18 July 1879 Dodgson wrote in his diary: "Called . . . on Mrs. Taylor (wife of the organist of New [College]) and made acquaintance with her four children—Leila, May, Stuart, and Leonard. Leila has a remarkably poetical face, and ought to photo well." Leila Campbell Taylor (b. 1868?) was photographed the following day. [2606]

PLATE 68. *Dorothy Kitchin*, 25 May 1880. Modern platinum print from original wet-collodion glass plate. 6 x 5 in. (15.24 x 12.7 cm). Private collection.

Xie Kitchin's younger sister, Dorothy Maud Mary (1874–1953), was photographed in the Christ Church rooftop studio. Dodgson noted in his diary: "Mrs. Kitchin brought Xie and Dorothy, and I did several photos." This was one of Dodgson's last photographs. He gave up photography in July of that year. In a sense, Dodgson was beginning to repeat himself; this photograph is reminiscent of several taken of Xie (see pl. 3) eleven years earlier. This may have been one of the reasons why Dodgson eventually abandoned his "one recreation." [2640]

PLATE 69. *Irene MacDonald*, July 1863. 9 3/4 x 7 11/16 in. (24.8 x 19.5 cm). Scottish National Photography Collection.

Irene MacDonald posed in a nightdress, holding a hairbrush. Dodgson gave another photograph taken at the same time the title *"It Won't Come Smooth,"* which is just as appropriate for this image. The photograph was taken at Elm Lodge, Hampstead. [1028?]

PLATE 70. *Julia Arnold*, *Seated on Unmade Bed*, ca. 1872. 5⅞ x 5 in. (15 x 12.7 cm). Courtesy Robert Koch Gallery.

Julia Frances Arnold (1862–1908), age ten, is photographed in night clothes sitting beside an unmade bed. The setting is not a real bedroom, but Dodgson's studio at Christ Church. Dodgson wrote on 15 June 1872: "Took photographs of Uncle Skeffington in the morning, and Julia and Ethel Arnold in the afternoon; one of Julia seated on side of bed." Julia was the seventh child of Thomas Arnold and his wife, Julia, née Sorell. Young Julia was a popular model for Dodgson; she was photographed at least twenty times between 1871 and 1878. [2046]

PLATE 71. *Beatrice Hatch*, 24 March 1874. 5½ x 4¹/₁₆ in. (14 x 10.3 cm). Gernsheim Collection, Harry Ransom Humanities Research Center, The University of Texas at Austin.

Beatrice Sheward Hatch (1866–1947) sat for this portrait at Dodgson's Christ Church rooftop studio. She was the daughter of Edwin Hatch (1835–1889), vice-principal of St. Mary's Hall, Oxford, and his wife, Bessie Cartwright, née Thomas. [2226]

PLATE 72. *Charlotte Edith Denman*, 8 July 1864. 4¼ x 3¼ in. (10.8 x 8.2 cm). Gernsheim Collection, Harry Ransom Humanities Research Center, The University of Texas at Austin.

During the summer of 1864, Dodgson set up his camera at Lambeth Palace, London, where many of his friends came to be photographed. He noted in his diary on 8 July 1864: "On reaching Lambeth I found Mrs. Denman and her three children, Edith (9), Arthur (6) and Grace (5). . . . Mrs. Denman also was obliged to go about 1, but she left the children, whom I went on photographing till about 3, and then took them home." Charlotte Edith (1855–1884) was the eldest daughter of Chief Justice George Denman (1819–1896). [1307]

PLATE 73. *Zoë Strong*, 10 October 1863. 4�³/₁₆ x 3⅜ in. (10.7 x 8.5 cm). Gernsheim Collection, Harry Ransom Humanities Research Center, The University of Texas at Austin.

Zoë Sophia Strong (b. 1854) was the daughter of Henry Linwood Strong (1816–1886) and Fanny Strong, née Erskine (1822–1908). Dodgson was acquainted with Mrs. Strong because she was the daughter of Henry David Erskine, the dean of Ripon. Mr. Strong was a barrister and registrar of the divorce courts. The photograph was taken in the garden of the MacDonald family home at 12 Earl's Terrace, Kensington, London. [1167]

PLATE 74. *Catherine "Katie" Gram Brine*, 16 June 1866. 5¹/₁₆ x 3¹⁵/₁₆ in. (12.9 x 10 cm). Gernsheim Collection, Harry Ransom Humanities Research Center, The University of Texas at Austin.

This rather formal portrait of Catherine "Katie" Gram Brine (b. 1860), daughter of James Gram Brine (1819–1901), the rector of All Saints Church, Chardstock, Dorset, and his wife, Mary Amelia, née Pusey (b. 1834), was taken in Dodgson's studio at Badcock's Yard. Mrs. Brine was the youngest daughter of Dr. Edward Bouverie Pusey (1800–1882), Regius Professor of Hebrew at Oxford, and one of the originators of the "Tractarian" movement of the late 1830s. [1484]

PLATE 75. *Laura Dodgson*, September 1862. 7³/₁₆ x 5⁹/₁₆ in. (18.3 x 14.1 cm). Courtesy of the Royal Photographic Society, Bath, England.

Laura Elizabeth Dodgson (1853–1882) was the youngest daughter of Hassard Hume Dodgson—one of Charles Dodgson's many cousins—and his wife, Caroline, née Hume. The photograph was taken at Park Lodge, Putney, the home of Hassard Dodgson and his family. Laura's life was cut short by a brain infection that caused her to go blind, and she died at the age of twenty-nine. [859]

PLATE 76. *Ellen Watts (Ellen Terry)*, 13 July 1865. 3⅜ x 4¹⁵/₁₆ in. (8.5 x 12.5 cm). Musée d'Orsay, Paris.

Ellen Alice Terry is captured in a solemn mood at the family home at 92 Stanhope Street, London. Her ten-month marriage to the painter George Frederick Watts had come to an end a month earlier. Dodgson first met Ellen Terry on 21 December 1864, at which time he noted: "I was very much pleased with what I saw of Mrs. Watts, lively and pleasant, almost childish in her face, but perfectly ladylike."

Auerbach, Nina. *Private Theatricals: The Lives of the Victorians.* Cambridge, Mass.: Harvard University Press, 1990.

Bajac, Quentin. *Tableaux Vivants: Fantaisies photographiques victoriennes (1840–1880).* Paris: Réunion des Musées Nationaux, 1999.

Bartram, Michael. *The Pre-Raphaelite Camera: Aspects of Victorian Photography.* Boston: Little Brown, 1985.

Bettelheim, Bruno. *The Uses of Enchantment: The Meaning and Importance of Fairy Tales.* New York: Vintage Books, 1989.

Carroll, Lewis. *Symbolic Logic and The Game of Logic.* New York and Berkeley: Dover, 1958.

Christ, Carol T. *The Finer Optic: The Aesthetic of Particularity in Victorian Painting.* New Haven: Yale University Press, 1975.

Cohen, Michael. *Engaging English Art: Entering the Work in Two Centuries of English Painting and Poetry.* Tuscaloosa and London: University of Alabama Press, 1987.

Cohen, Morton N. *Lewis Carroll: A Biography.* New York: Alfred A. Knopf, 1995.

———. *Lewis Carroll, Photographer of Children: Four Nude Studies.* Philadelphia: Rosenbach Foundation, 1978.

———. *Reflections in a Looking-Glass: A Centennial Celebration of Lewis Carroll, Photographer.* New York: Aperture, 1998.

———, ed. *The Letters of Lewis Carroll.* New York: Oxford University Press, 1979.

Collingwood, Stuart Dodgson. *The Life and Letters of Lewis Carroll (Rev. C. L. Dodgson).* London: T. Fisher Unwin, 1898.

———, ed. *The Lewis Carroll Picture Book.* London: T. Fisher Unwin, 1899.

The Complete Works of Lewis Carroll. Introduction by Alexander Woollcott. London: Nonesuch Press, 1939.

Desmond, Adrian. *Archetypes and Ancestors: Palaeontology in Victorian London, 1850–1875.* Chicago: University of Chicago Press, 1982.

Dodier, Virginia. *Lady Hawarden: Studies from Life, 1857–1864.* New York: Aperture, 1999.

Empson, William. *Some Versions of Pastoral.* London: Chatto and Windus, 1935.

Flaxman, Rhoda L. *Victorian Word Painting and Narrative: Toward the Blending of Genre.* Ann Arbor, Mich.: UMI Research Press, 1987.

Ford, Colin, ed. *Lewis Carroll at Christ Church.* London: National Portrait Gallery, 1974.

Foucault, Michel. *The History of Sexuality.* Vol. 1, *An Introduction.* New York: Random House, 1978.

Frith, Francis. *Egypt and Palestine Photographed and Described.* London: James Virtue, 1858–60.

Gardner, Martin. *The Annotated Alice: Alice's Adventures in Wonderland and Through the Looking-Glass by Lewis Carroll.* New York: Meridian, 1960.

Gattéano, Jean. *Lewis Carroll: Fragments of a Looking-Glass.* Rosemary Sheed, trans. New York: Thomas Y. Crowell, 1974.

Gauld, Alan. *The Founders of Psychical Research.* London: Routledge & Kegan Paul, 1968.

Gay, Peter. *The Naked Heart: The Bourgeois Experience, Victoria to Freud.* New York and London: W. W. Norton, 1995.

Gernsheim, Helmut. *Julia Margaret Cameron: Her Life and Photographic Work.* London: Fountain Press, 1948.

———. *Lewis Carroll: Photographer.* New York: Chanticleer Press, 1949.

Goldman, Paul. *Victorian Illustrated Books: The Heyday of Wood-Engraving.* London: British Museum Press, 1994.

Goldschmidt, A. M. E. "'Alice in Wonderland' Psycho-Analysed." *The New Oxford Outlook,* no. 1 (May 1933).

Green-Lewis, Jennifer. *Framing the Victorians: Photography and the Culture of Realism.* Ithaca, N.Y.: Cornell University Press, 1996.

Greenacre, Phyllis, M. D. *Swift and Carroll: A Psychoanalytic Study of Two Lives.* New York: International Universities Press, 1955.

Hacking, Juliet. *Princes of Victorian Bohemia: Photographs by David Wilkie Wynfield.* London: National Portrait Gallery, 2000.

Harker, Margaret F. *Henry Peach Robinson: Master of Photographic Art, 1830–1901.* Oxford: Basil Blackwell, 1988.

Helsinger, Elizabeth K. *Ruskin and the Art of the Beholder.* Cambridge, Mass.: Harvard University Press, 1982.

Higonnet, Anne. *Pictures of Innocence: The History and Crisis of Ideal Childhood.* London: Thames and Hudson, 1998.

Jones, Edgar Yoxall. *The Father of Art Photography: O. G. Rejlander, 1813–1875.* Newton Abbott, England: David and Charles, 1973.

Kincaid, James R. *Child-Loving: The Erotic Child and Victorian Culture.* New York and London: Routledge, 1992.

Leach, Karoline. *In the Shadow of the Dreamchild: A New Understanding of Lewis Carroll.* London: Peter Owen, 1999.

Lennon, Florence Becker. *Victoria Through the Looking-Glass*. New York: Simon & Schuster, 1945.

Levine, George. *Darwin and the Novelists: Patterns of Science in Victorian Fiction*. Chicago and London: University of Chicago Press, 1991.

Lewis Carroll. Introduction by Colin Ford. Paris: Editions Nathan/Photo Poche, 1998.

Lewis Carroll. Essays by Marina Warner, Roger Taylor, and Michael Bakewell. London: The British Council, 1998.

Lewis Carroll's Alice: The Photographs, Books, Papers, and Personal Effects of Alice Liddell and Her Family. London: Sotheby's, Catalogue for auction sale, 2 June 2001.

Lewis Carroll and Alice: The Private Collection of Justin G. Schiller. New York: Christie's, Catalogue for auction sale, 9 December 1998.

"Lewis Carroll's Photographs of Children: Commentary by Mindy Aloff, T. J. Clark, Ann Hulbert, Janet Malcolm, Lisa Mann, Adam Phillips, and Christopher Ricks." *Threepenny Review* 16, no. 4 (Winter 1996): 22–29.

Lewis Carroll, Victorian Photographer. Introduction by Helmut Gernsheim. London: Thames and Hudson, 1980.

Lukitsh, Joanne. *Julia Margaret Cameron: Her Work and Career*. Rochester, N.Y.: George Eastman House,1986.

Maas, Jeremy et al. *Victorian Fairy Painting*. London: Merell Holberton, 1997.

Marcus, Steven. *The Other Victorians: A Study of Sexuality and Pornography in Mid-Nineteenth Century England*. London: Weidenfeld and Nicolson, 1964.

Mavor, Carol. *Becoming: Photographs of Clementina, Viscountess Hawarden*. Durham, N.C., and London: Duke University Press, 1999.

Munich, Adrienne Auslander. *Andromeda's Chains: Gender and Interpretation in Victorian Literature and Art*. New York: Columbia University Press, 1989.

Newhall, Beaumont. *The History of Photography from 1839 to the Present*. New York: The Museum of Modern Art, 1982.

Ovenden, Graham, ed. *Pre-Raphaelite Photography*. New York: St. Martin's Press, 1972.

Pearsall, Ronald. *The Worm in the Bud: The World of Victorian Sexuality*. Toronto: Macmillan, 1969.

Photographic Society—Exhibition of Photographs and Daguerreotypes at the South Kensington Museum. London: Taylor and Francis, 1858.

Postman, Neil. *The Disappearance of Childhood*. New York: Random House, 1994.

Reed, Langford. *The Life of Lewis Carroll*. London: W. and G. Foyle, 1932.

Reichertz, Ronald. *The Making of the Alice Books: Lewis Carroll's Uses of Earlier Children's Literature*. Montreal and Kingston: McGill-Queen's University Press, 1997.

Reynolds, Joshua. *Discourses on Art*. Edited by Robert R. Wark. London and New Haven: Yale University Press, 1997.

Savy, Nicole, and Philippe Néagu, eds. *Les petites Filles modernes*. Paris: Réunion des Musées Nationaux, 1989.

Shaberman, R. B. "Which Dreamed It?" In *Under the Quizzing Glass: A Lewis Carroll Miscellany*. London, Magpie Press, 1972.

Smith, Alison. *The Victorian Nude: Sexuality, Morality and Art*. Manchester: Manchester University Press, 1996.

Smith, Lindsay. *The Politics of Focus: Women, Children and Nineteenth-Century Photography*. Manchester: Manchester University Press, 1998.

——. *Victorian Photography, Painting and Poetry: The Enigma of Visibility in Ruskin, Morris, and the Pre-Raphaelites*. Cambridge: Cambridge University Press, 1995.

Spencer, Stephanie. "O. G. Rejlander Art Studies." In *British Photography in the Nineteenth Century: The Fine Art Tradition*, edited by Mike Weaver. Cambridge and New York: Cambridge University Press, 1989.

——. *O. G. Rejlander: Photography as Art*. Ann Arbor, Mich.: UMI Research Press, 1985.

Spitz, Ellen Hander. *Art and Psyche: A Study in Psychoanalysis and Aesthetics*. New Haven and London: Yale University Press, 1985.

Steinorth, Karl, ed. *Lewis Carroll: Photographien · Photographs*. Essay by Colin Ford. Schaffhausen, Germany: Edition Stemmle, 1991.

Stern, Jeffrey, ed. *Lewis Carroll's Library: A Facsimile Edition of the Catalogue of the Auction Sale Following C. L. Dodgson's Death in 1898, with Facsimiles of Three Subsequent Booksellers' Catalogues Offering Books from Dodgson's Library*. Silver Spring, Md.: The Lewis Carroll Society of North America [Carroll Studies No. 5], 1981.

Stevenson, Sara, and Helen Bennett. *Van Dyck in Check Trousers: Fancy Dress in Art and Life, 1700–1900*. Edinburgh: Scottish National Portrait Gallery, 1978.

Stoffel, Stephanie Lovett. *Lewis Carroll and Alice*. London: Thames and Hudson, 1997.

Taylor, Alexander L. *The White Knight*. Edinburgh: Oliver and Boyd, 1952.

Taylor, Roger, and Edward Wakeling. *Lewis Carroll, Photographer: The Princeton University Library Albums*. Princeton, N. J.: Princeton University Press/Princeton University Library, 2002.

Waggoner, Diane Margaret. "In Pursuit of Childhood: Lewis Carroll's Photography and the Victorian Visual Imagination." Ph.D. diss., Yale University, 2000.

———. "Photographing Childhood: Lewis Carroll and Alice." In *Picturing Children: Constructions of Childhood between Rousseau and Freud*, edited by Marilyn R. Brown. Aldershot, England, and Burlington, Vt.: Ashgate, 2002.

Wakeling, Edward, ed. *Lewis Carroll's Diaries: The Private Journals of Charles Lutwidge Dodgson*. 6 vols. Luton, England: The Lewis Carroll Society.

> Vol. 1—January to September 1855 [1993]
> Vol. 2—January to December 1856 [1994]
> Vol. 3—January 1857 to April 1858 [1995]
> Vol. 4—May 1862 to September 1864 [1997]
> Vol. 5—September 1864 to January 1868 [1999]
> Vol. 6—April 1868 to December 1876 [2001]

Weaver, Mike. *Julia Margaret Cameron, 1815–1879*. Southampton, England: John Hansard Gallery, 1984.

———. *Whisper of the Muse: The Overstone Album & Other Photographs by Julia Margaret Cameron*. Malibu, Calif.: J. Paul Getty Museum, 1986.

———, ed. *British Photography in the Nineteenth Century: The Fine Art Tradition*. Cambridge and New York: Cambridge University Press, 1989.

White, Clarence H. "Old Masters in Photography." *Platinum Print* 1, no. 7 (February 1915): 5.

Wolf, Sylvia. *Julia Margaret Cameron's Women*. Chicago: Art Institute of Chicago, 1998.